IMAGES
of America

WYOMING'S
OUTLAW TRAIL

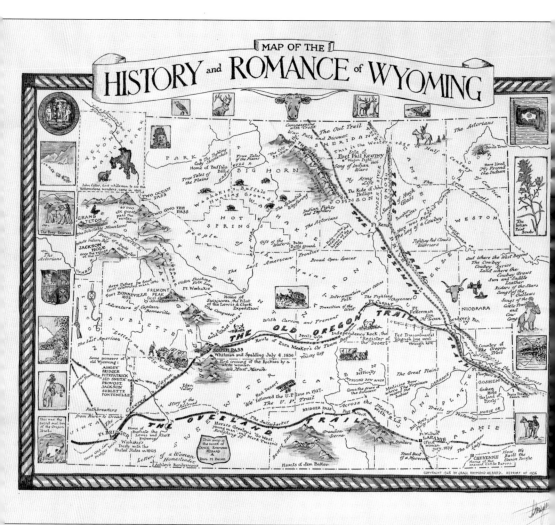

This 1928 map of Wyoming by historian Grace Raymond Hebard details the existing landscapes, routes, and communities of the "Cowboy State." It is unlikely that there was one clearly defined "Outlaw Trail." There were probably many sections of the trail that loosely followed Wyoming's main emigrant thoroughfares and stagecoach routes, paths that are visible on the map. Near communities where there were heavy concentrations of lawmen or allies of the Wyoming Stock Growers Association such as Buffalo, Cheyenne, and Sheridan, the outlaws would have cut through open terrain to avoid capture. (Courtesy of the American Heritage Center.)

ON THE COVER: This iconic undated photograph of a cowboy and his horse in the Greybull River country of northern Wyoming was shot by photographer Charles J. Belden. Belden worked on the Pitchfork Ranch of Meeteetse, Wyoming, an outfit that was formerly owned in the 1890s by Butch Cassidy's sworn enemy, Otto Franc. It was through this landscape that Cassidy would have herded his stolen horses. (Courtesy of the American Heritage Center.)

IMAGES
of America

WYOMING'S
OUTLAW TRAIL

Mac Blewer

ARCADIA
PUBLISHING

Published by Arcadia Publishing
Charleston, South Carolina

Printed in the United States of America

Library of Congress Control Number: 2012940632

For all general information, please contact Arcadia Publishing:
Telephone 843-853-2070
Fax 843-853-0044
E-mail sales@arcadiapublishing.com
For customer service and orders:
Toll-Free 1-888-313-2665

Visit us on the Internet at www.arcadiapublishing.com

To my father, John MacGregor Blewer, and my mother, Barbara Blewer, who instilled in me a love of history, folklore, and geography.

CONTENTS

ACKNOWLEDGMENTS

Thanks are due to the academic mentorship of John Logan Allen, John Dorst, Linda Fabian, John Patrick Harty, Tamsen Hert, Deborah Paulson, Eric Sandeen, and Dr. Gerald Webster.

Fellow outlaw enthusiasts who were instrumental with their guidance include Bill Betenson, Nancy Coggeshall, and Larry Pointer. Friends and colleagues who I am indebted to include: Deborah Amend, Tom Bell, Mike Bell, Curtis Elmendorf, Joyce and Mike Evans, Christy and Jason Fleming, Elnora Frye, Dan Gibson-Reinemer, Daniel Gilmore, Orlando Hiller, Bart Koehler, Patty Pendergast, Gary Puls, Andrew Romero, Alan Spears, Misty Stoll, Julia Stuble, Russ Tanner, Steve Torbit, Rowene Weems, Corrie Welch, and Charlie and Jen Wilson.

A large thank-you to Rick Ewig, associate director of the American Heritage Center, and to John Waggener, archivist at the American Heritage Center, for their invaluable mentorship and technical expertise.

My family, Victoria Blewer, Chris Bohjalian, Julia Cox, and Robert Cox, were extremely supportive of this dream.

All images are property of the American Heritage Center unless otherwise noted. Lastly, I am grateful to the following organizations for the procurement of images that appear in this book: the Adams Museum, Biodiversity Conservation Alliance, the Buffalo Bill Historical Center, the Bureau of Land Management, the Denver Archives, the Homesteader Museum, the Jim Gatchell Memorial Museum, the Library of Congress, the National Park Service, the Park County Archives, the Sweetwater County Historical Association, the Union Pacific Railroad Museum, the Utah State Historical Society, the Wyoming State Archives, and the Wyoming Territorial Prison State Historic Site.

The University of Wyoming's American Heritage Center, the Wild West History Association, and the Wyoming State Historical Society provided much-appreciated financial support for fieldwork and archival research.

INTRODUCTION

Steeped in Western mythology, some say the Outlaw Trail never existed and was purely folklore. Others believe that it was a historic path that meandered over 1,500 miles from Canada to Mexico. As Robert Redford opined in his book *The Outlaw Trail*, "[Its] name . . . held a kind of magic, a freedom, a mystery." Regardless of just how much of the Outlaw Trail was fastened in the public's imagination or on the physical landscape, it is clear that the outlaws did use a robber highway of sorts. Sometimes following prominent routes like the Oregon Trail and at other times cutting through open terrain, the outlaws had to move quickly to avoid their dogged pursuers.

The Outlaw Trail was also known as the "Owl Hoot." According to writer Larry Pointer, " 'The Owl Hoot' may have signified night time. The outlaws were 'long riders,' a reference to their desire to put a lot of distance between themselves and their most recent transgression. They did not stop to turn in wherever they found themselves come nightfall. They often secreted themselves during the daytime in more populated areas or where they knew there were officers hunting for them, then under cover of dark made their way onward."

Bandits like Butch Cassidy found refuge in many of the natural safe havens that the state's topography afforded. They also found security in communities whose citizens were sympathetic to the outlaws, whom they saw, in part, as defenders of a diminishing way of life due to the encroachment of the railroads and cattle barons.

The end of the Outlaw Trail marked the imprisonment, death, or disappearance of the "horseback outlaws." However, in their death and the death of the Old West came a rise of the New West in the early 1900s, a West that remembered with nostalgia the golden age of the outlaw, as dark as that age may have been. Although it is unclear where the mythological West ends and the historic West begins, the era of the outlaw is firmly ingrained in American culture.

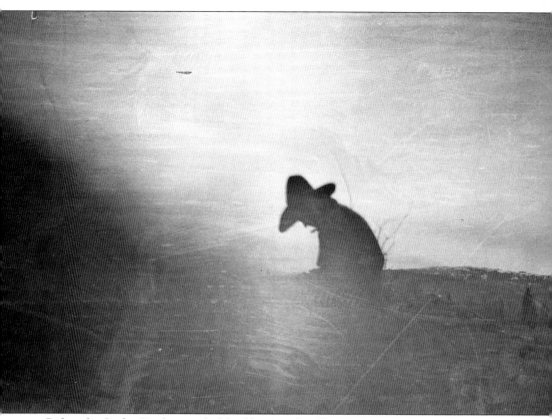

Riding the Outlaw Trail ensured a life of freedom, hardship, and uncertainty. Former Wild Buncher Matt Warner recounts, "It was hell proper. It wasn't a case of just one outfit of deputies trailing us, but posses was out scouring the whole country. . . . We didn't dare to build fires at night or even in the daytime. . . . In the daytime we would sweat, fry or sizzle under the hot desert sun, or ride for whole days with our clothes soaking wet in rainy weather. . . . On hot days . . . the sweat would roll down our bellies and backs, and the hard, heavy money belts would gall a raw ring around our bodies, and the money got heavier and heavier and the sore rawer and rawer every mile we rode, till we thought we couldn't stand it any longer."

One

TOUGH TIMES IN WYOMING

To understand the rise of lawlessness in Wyoming in the 1880s and 1890s, it is important to understand why the ground was so fertile for bandits. As Dr. Orrin Klapp asserts, "An age of mass hero worship is an age of instability," and the Wyoming of the late 19th century was indeed a volatile, unstable landscape. Indian attacks, the aftermath of the Civil War, feuding between small ranchers and cattle barons, vigilante hangings, and the environmental degradation of the range all combined to form a very fragile period for the state.

"During the years 1885 and 1886 everyone seemed to be hard up in Wyoming," recalled John Clay. The before-mentioned challenges coupled with the financial insecurities faced by the Wyoming Stock Growers Association; the disastrous winter of 1886–1887, where near polar temperatures led to massive livestock die-offs; and increased rustling threatened many ranchers' livelihoods.

Although the Wyoming Stock Growers Association conducted numerous investigations into rustling incidents, its efforts, especially in the Powder River country of Johnson County, seemed in vain. There was only one solution in the minds of some of the Stockmen: open war. As William Kittrell states in the foreword of A.S. Mercer's book *The Banditti of the Plains*, "the invasion they planned was no ordinary raid on a bunch of cow thieves. . . . It was a war of extermination." In all, 26 Texan gunmen were recruited by Wyoming ranchers, each one promised $50 for every rustler killed. A "black list" was named of citizens who needed to be killed. Northward they journeyed.

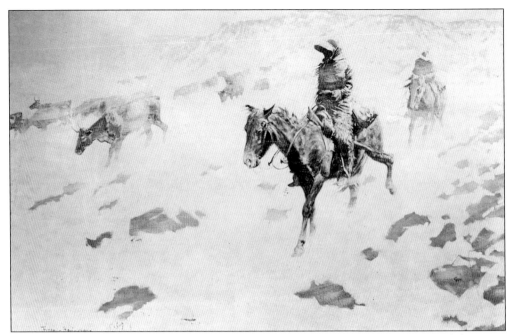

The winter of 1886 and 1887 was devastating to livestock herds across Wyoming and the West. The painting *Drifting before the Storm*, by Frederick Remington, displays the conditions that ranchers faced during these tough times. The harsh weather impacted small and large ranchers alike and had profound social ramifications. (Courtesy of the Library of Congress.)

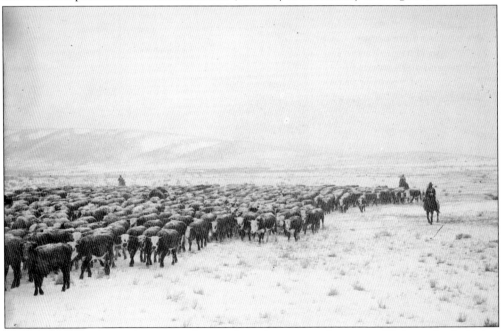

In this photograph, cowboys move livestock at the outset of a storm. With cattle declining precipitously during this time period, many ranch hands found themselves out of work. For many, turning to a life of crime was a palatable option. Gangs gave these men financial security and identity, and their skills as outdoorsmen and riders could be put to good use.

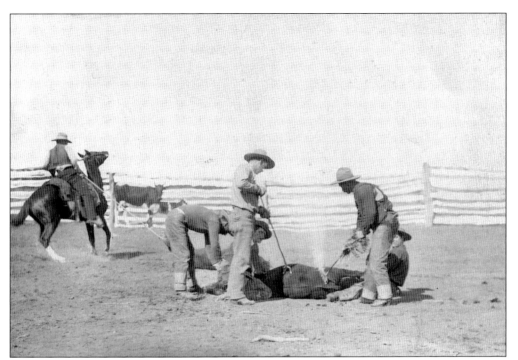

Rustlers frequently rebranded cows to hide the animals' identities. Here cowboys are branding a calf. For those who were "a little on the rustle," it was a way of life. To the powerful Wyoming Stock Growers Association, it was another threat that challenged the ranchers' control of the range. (Courtesy of the Library of Congress.)

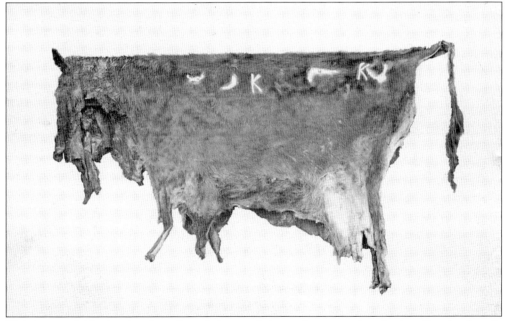

This is a cowhide that has been branded several times, demonstrating the handiwork of cattle thieves. Starting in 1871, Wyoming law specified that the altering of brands would lead to a fine of up to $500 or a prison sentence of up to five years. It did little to deter rustlers' activities.

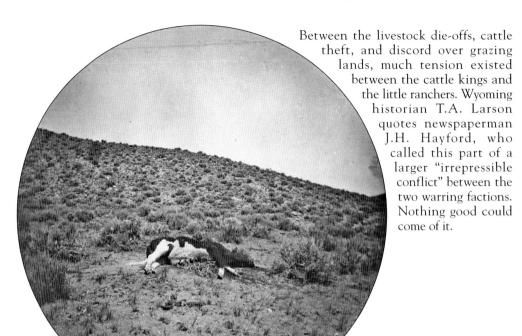

Between the livestock die-offs, cattle theft, and discord over grazing lands, much tension existed between the cattle kings and the little ranchers. Wyoming historian T.A. Larson quotes newspaperman J.H. Hayford, who called this part of a larger "irrepressible conflict" between the two warring factions. Nothing good could come of it.

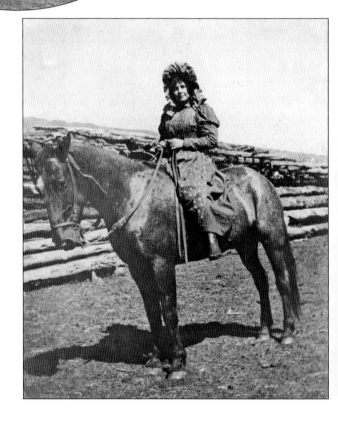

Several Sweetwater country ranchers accused Ella Watson and her husband, James Averill, of rustling and on July 20, 1889, hanged them from a tree. The murder of Ella Watson, also known as "Cattle Kate," shocked the West. A *Salt Lake Tribune* editorial stated, "The men of Wyoming will not be proud of the fact that a woman . . . had been hanged within their territory. That is about the poorest use a woman could be put to."

James Averill, Watson's husband or lover, may have ruffled the feathers of neighboring cattlemen when he wrote editorials to the Casper newspaper accusing them of pushing him out of desirable pastures. He and Watson also owned land that was coveted by some of these stockmen, including A.J. Bothwell. Regardless of what motivated their killers, Averill and Watson met a cruel fate.

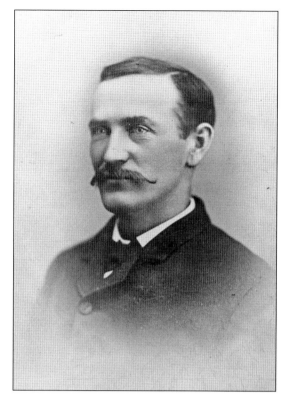

The ranchers who hanged Ella Watson and James Averill were A.J. Bothwell, Bob Connor, John Durbin, R.M. Galbraith, E. Mclain, and Tom Sun. In this group photograph sit Tom Sun (center) and the Rankin brothers, several of whom were ranchers and one of whom was a prominent deputy sheriff. Sheriff Frank Hadsell (bottom right) is the lawman who arrested Sun and his compatriots after the killing.

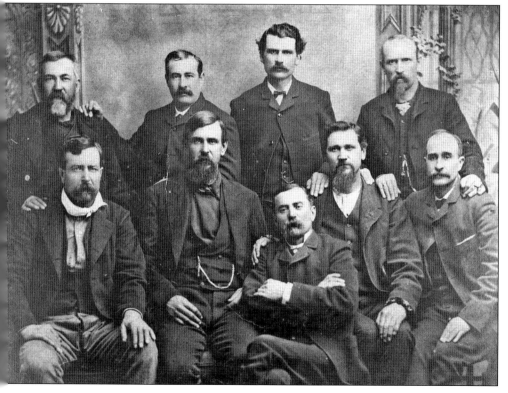

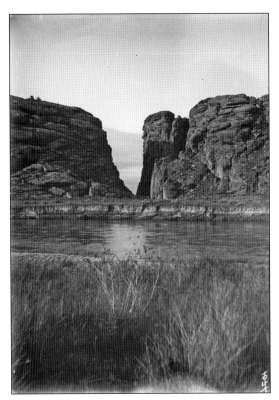

The crime occurred near Devil's Gate in the Sweetwater country of Wyoming. It was near here that Ella Watson and Jim Averill were found swinging from a tree. The ranchers who were accused of the double killing were never punished. It is still disputed if the couple were rustlers.

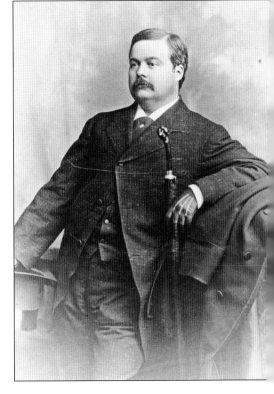

Maj. Frank E. Wolcott was a former US Marshal and a receiver for the US Land Office. According to historian T.A. Larson, he was disliked during these tenures and viewed by the public as dishonest and corrupt. His reputation would not improve with citizens when he helped lead the "Johnson County Invaders."

Col. Jay Torrey was one of the ranchers supportive of the Stock Growers' efforts to eradicate rustlers. He is shown here in a costume in a photograph from a family scrapbook. During the Spanish-American War he organized a Wyoming cavalry unit, the 2nd US Volunteer Cavalry, also known as "Torrey's Rough Riders." The unit never made it to Cuba due to a train accident in Mississippi.

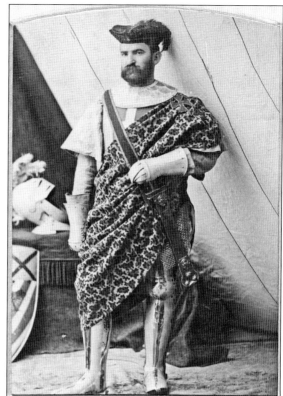

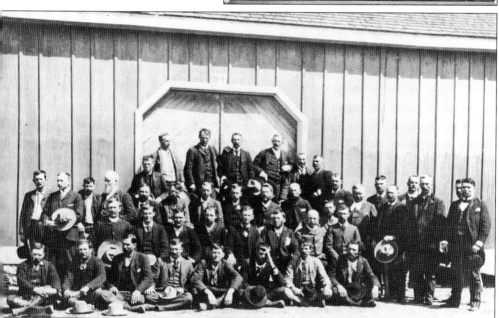

n 1892, the Wyoming Stock Growers Association hired 26 Texas gunmen and, with another company of ranchers including Maj. Frank Wolcott, journeyed north to Johnson County to meet the rustlers. The photograph above is of the Johnson County Invaders. Thus began the most infamous chapter of the "irrepressible conflict" in Wyoming.

The citizens who were on the invaders' extensive "death list" included Nate Champion (left), a suspected rustler. Surrounding Champion's KC Ranch, the invaders gunned down Nick Ray, another rustler. Champion, hiding inside, held off his attackers. Finally setting a wagon on fire and pushing it up to the cabin, the vigilantes smoked him out. Champion bolted out the back only to be shot nearly 30 times. His diary reads: "Boys, I feel pretty lonesome just now. I wish there was someone here with me so we could watch all sides at once. . . . I heard them splitting wood. I guess they are going to fire the house tonight. I think I will make a break when night comes, if alive. Shooting again. . . . The house is all fired. Goodbye, boys, if I never see you again."

While the Invaders were occupied at the KC Ranch, Sheriff "Red" Angus from Buffalo was busy gathering an army of his own. Over 400 citizens rallied to his call. The Invaders had lost precious time at the KC. Pressing forward towards Buffalo, they were met by some allies who warned them of Angus's approaching force.

The Invaders took shelter at the TA Ranch. Surrounded on all sides by a superior force, their situation was bleak. Gov. Amos Barber asked Pres. Benjamin Harrison to rescue the beleaguered force, stating in a telegram that "an insurrection exists in Johnson County." The cavalry rode to their rescue. (Courtesy of the Jim Gatchell Memorial Museum.)

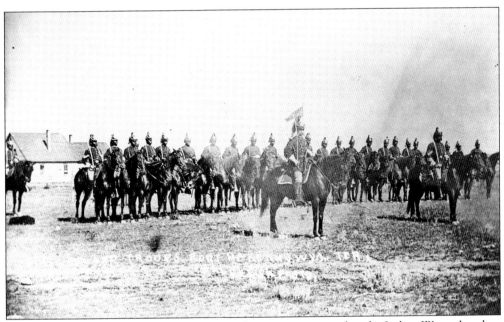

Buffalo Soldiers, African American regulars who were experienced in the Indian Wars, played an important part in ending the invasion. The 10th Regiment, stationed in Fort McKenny, Wyoming, was ordered by President Harrison to rescue the besieged Invaders. To the consternation of Buffalo citizens, the regulators were taken to Fort Russell in Cheyenne.

In the following weeks, funerals would be held for the men killed in the invasion. This photograph shows the charred remains of Nick Ray, whose body was burned beyond recognition. Wyoming's congressional delegation and governor denied any foreknowledge of the escapade. (Courtesy of the Jim Gatchell Memorial Museum.)

A newspaper headline demonstrates citizens' outrage. Some discussed sending an invasion force to Cheyenne to recapture the Invaders. This never did occur, although the resentment that the Buffalo citizens felt was justified. Not one of the regulators would see a jail cell. The Johnson County Invasion set the stage not only for heightened tensions between the various ranching factions but also for the rise of the Wild Bunch.

FIENDS!

THE MOST BRUTAL MURDERS EVER COMMITTED!

THE WRETCHES CAPTURED AND CONFINED IN FT. McKINNEY.

MANY OF THEM "RANGE BARONS" AND PROMINENT CHEYENNE BUSINESS MEN.

MAJOR WOLCOTT AND BILLY IRVINE COMMANDED THE GANG OF MURDERERS.

Were they Employed and Sent out by State Authorities?

How they were Captured and a Complete List of Their Names.

FULL PARTICULARS TO DATE.

If THE GRAPHIC had been called on to produce proof of its allegations

Two

HITTING THE OWL HOOT

Matt Warner remembers what hitting the Outlaw Trail (the "Owl Hoot") was like:

> We was running into fresh outfits every little while and had to suddenly change direction, or dodge into a rock or timber hideout, or backtrack, or follow long strips of bare sandstone where we wouldn't leave tracks or wade up and down streams long distances so they would lose our tracks. We had to put into practice all the tricks we had learned as cowboys and learn all the new tricks outlaws had to know to stay alive . . .
>
> It didn't make any difference if one of us got sick, or nearly died with rheumatism or toothache, or got a leg broke; he had to grit his teeth and trail along anyway. If he died he died just like a horse or a dog along the trail and didn't receive any more burial than they would, and his body would be eaten by the coyotes . . .
>
> [And] while we was freezing, starving, and depriving ourselves of every comfort and pleasure of existence, here was all that stolen money in our belts that would buy anything we wanted, and we couldn't go anywhere or contact anyone to spend it. We just had to leave it there making raw rings around us, weighing us down and wearing us out, while we was nearly perishing for the things it could buy us.

Countless bandits hit the Outlaw Trail. In Wyoming, it meandered from the Big Horns in the north to the Red Desert in the south and west to the forested mountains of Star Valley. It wound its way through an area that is firmly ingrained in the minds of Americans as representative of the frontier, a time when the country was young. Some of the bandits' most valued allies lived here, such as "Queen" Anne Bassett.

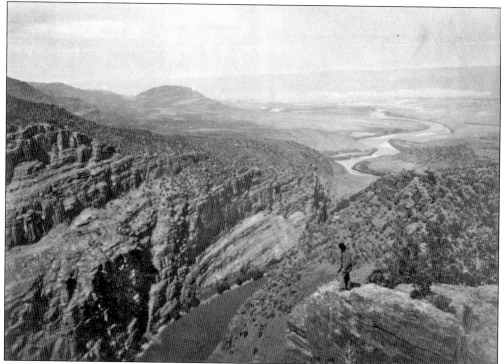

Browns Park, also known as Browns Hole, straddles Colorado, Utah, and Wyoming. Possibly named after a French Canadian fur trapper, Baptiste Brown, this diverse landscape consists of mountains, hills, and sagebrush flats through which the Green River meanders. Its geographic location was ideal for outlaws. (Courtesy of the Library of Congress.)

Browns Hole was one of many natural fortresses used by Butch Cassidy's Wild Bunch between 1896 and 1901. Diamond Mountain, a prominent landmark, rises above the valley. In this area, Cassidy's gang was known as the Diamond Mountain Boys. (Courtesy of the Charles Kelly Collection, Utah State Historical Society.)

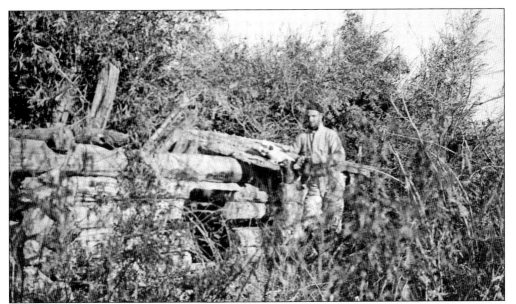

There are many cabins that Cassidy reputedly lived in. This one was photographed in Browns Park in the 1930s. Although it is nearly impossible to verify this structure's authenticity, it is probable that Cassidy would have well-placed hideouts on the Outlaw Trail. (Courtesy of the Charles Kelly Collection, Utah State Historical Society.)

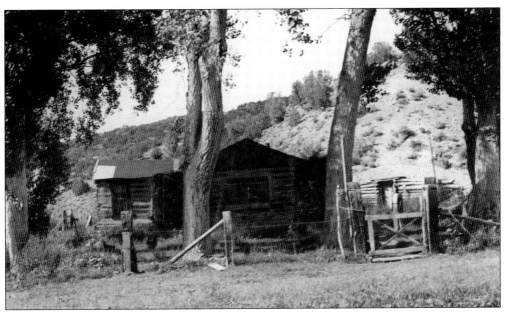

Cassidy probably first came to Browns Park in 1889. A little-known bandit, he had journeyed from Telluride, Colorado, where he had engaged in his first bank robbery with the McCarty brothers. He would work for several ranchers, including the Bassetts. Herb and Elizabeth Bassett raised two daughters, Anne and Josie Bassett, who would become prominent community leaders. Their ranch house is above. (Courtesy of the Charles Kelly Collection, Utah State Historical Society.)

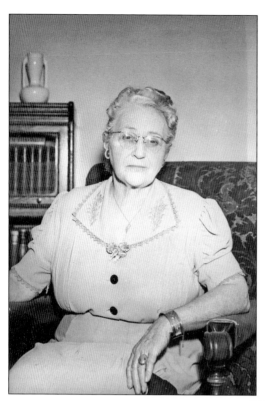

"Queen" Anne Bassett Willis was one of the last of the Browns Park homesteaders who remembered the outlaw era. Her family was friendly to many Browns Park bandits in the 1880s and 1890s, including Matt Warner, Elzy Lay, and Butch Cassidy. Cassidy worked for the Bassetts as a ranch hand in 1889, shortly after the Telluride bank robbery. He may have been romantically with her or her sister, Josie Bassett. Anne is seen here in a 1943 photograph. In 1911, she was accused of rustling cattle but was acquitted. She gained her nickname from a *Denver Post* reporter who was offended by her alleged rudeness. (Courtesy of the Charles Kelly Collection, Utah State Historical Society.)

Charlie and Mary Crouse of Browns Hole pose for a photograph at their ranch near Diamond Mountain. Charlie, a friend on the Bassetts and of Butch Cassidy once raced against the great outlaw. He lost the race, the wager, and his horse to Cassidy. The incident has become local folklore. (Courtesy National Park Service.)

Jon Jarvie was a Scot who ran a store in Browns Park and operated a ferry on the Green River. He was a well-respected member of the close-knit community of ranchers and a friend to many of the outlaws in the area. His dugout by the river may have been used by Cassidy as a hideout. (Courtesy of the National Park Service.)

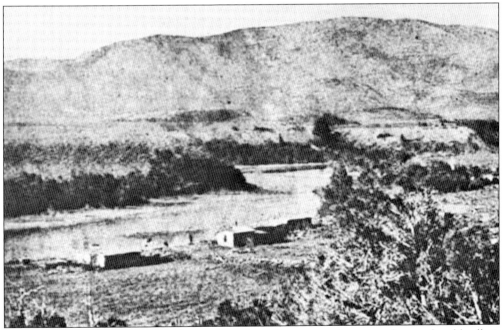

Browns Hole was an important refuge to Cassidy and his gang, who enjoyed a comfortable albeit mixed relationship with this community. As the December 2, 1937, *Wind River Mountaineer* states: "The Wyoming Bad Lands and the Colorado-Wyoming Snake River border country were to the gun-slinging Butch Cassidy what Sherwood Forest was to the arrow-shooting Robin Hood. Cassidy was known both as a boon and a blessing to residents of the Rocky Mountain east slope." The image here is of Jon Jarvie's homestead, one of the outlaw's haunts. (Courtesy of Bureau of Land Management.)

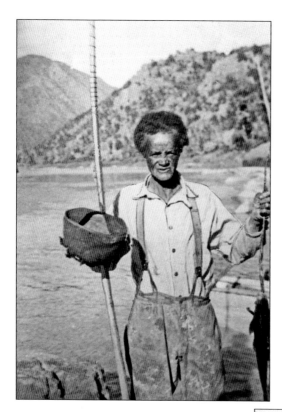

According to Diane Kouris, Albert "Speck" Williams may have first come to Browns Park "with a traveling minstrel show as their heel-clicking-buck-and-wing dancer" from Virginia. This affable man ran Jarvie's ferry and may have warned outlaws of approaching lawmen. (Courtesy of the Charles Kelly Collection, Utah State Historical Society.)

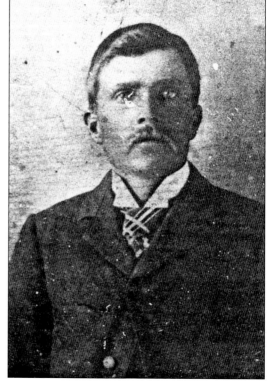

Originally from Acton, Texas, Matt Rash was a Browns Park rancher who may have been a "little on the rustle." He would be killed by Tom Horn on July 7, 1900, while he was at his cabin on Cold Spring Mountain. His decomposing corpse was found by a boy. (Courtesy of the National Park Service.)

Ironically, Rash may have hired his future killer, Tom Horn, as a cook when Horn first came to Browns Park. Horn, the infamous range detective and hired Pinkerton assassin, had introduced himself to residents as "James Hix" or "Tom Hix." Josie Bassett disliked him for his vulgarity and boastful ways.

Isom Dart was a ranch hand who worked for the Bassetts. Like Matt Rash, he may also have been placed on a Stock Growers' "death list." In October 1900, Dart emerged from his cabin on Cold Spring Mountain. According to George Bassett, who was with him, two shots were fired and Dart fell lifeless. Bassett and another boy found two .30-.30 casings under a tree over a hundred yards away—the .30-.30, Tom Horn's favorite weapon. (Courtesy of the Denver Public Library.)

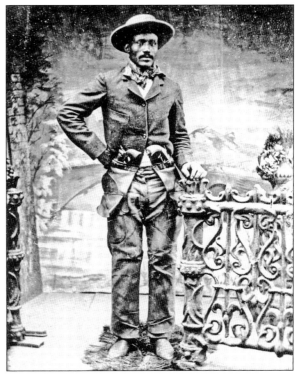

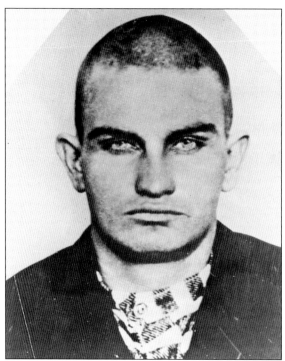

Harry Tracy was a dangerous outlaw on the run in Browns Park in 1898. He had escaped from a Utah prison and joined up with other bad men. Colorado lawman Valentine Hoy and posse members surrounded the outlaws, and as evening fell, they attacked. Tracy shot down Hoy. The outlaws escaped while the stunned posse recovered their fallen friend. In 1902, Tracy would kill himself in a cornfield in Creston, Washington, rather than be taken alive by police.

Like many cities in southern Wyoming, Green River sprang up as a "Hell on Wheels" community, a reference to the tented lawless towns that formed in the Union Pacific Railroad's wake between 1868 and 1870. Here, railroad workers are shown constructing a bridge. Castle Rock, then called Citadel Rock, looms.

This is Green River as depicted in an early 1900s postcard. The town in its early years was visited by some of the most notorious rustlers and robbers, including Isom Dart, Butch Cassidy, and Jack Morrow. Morrow, a ruffian and "bad man" of the late 1860s and early 1870s, frequented this city and others in southwestern Wyoming. He is immortalized by several landforms named after him in the adjacent Red Desert, including the Jack Morrow Hills. (Courtesy of the Sweetwater County Historical Association.)

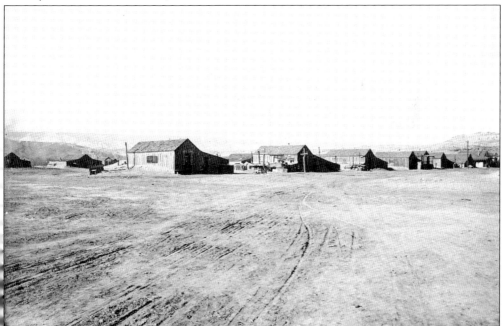

The city of Rock Springs in the 1880s was a curious mix of ranchers, railroaders, and coal miners. The area's huge coal deposits fueled not only the Union Pacific Railroad but also the town's economy. Men from around the world, including Finns, Slavs, and Chinese, worked the mines, making this the most ethnically diverse community in Wyoming. These are miners' homes.

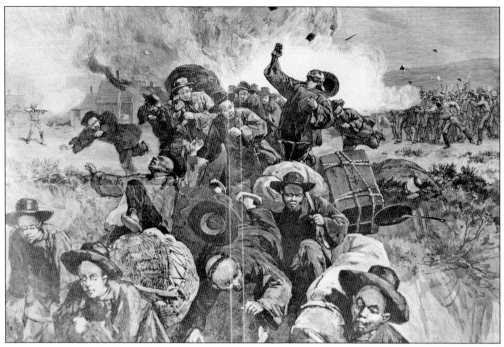

In 1885, a group of whites killed 28 Chinese, wounded 15, and burned a large section of Rock Springs. Anger against the Union Pacific Coal Company's hiring policies was one of many reasons behind the event, which became known as the Rock Springs Chinese Massacre. The episode was depicted in this image from *Harper's* magazine. Wyoming governor Francis E. Warren stated that "it was the most damnable and brutal outrage that ever occurred. . . . The men who did murder, arson and robbery were tramps and outlaws . . . the dregs of the lowest order."

Not far from Rock Springs lies the landscape of Adobe Town. In order to gain distance between members of his gang and the posse after the Tipton train robbery of August 29, 1900, Butch Cassidy kept fresh horses at several sites including the Haystacks of Adobe Town. The area provided an excellent vantage point to see pursuers. (Courtesy of the Biodiversity Conservation Alliance.)

Douglas Preston was a friend of Butch Cassidy and acted as his attorney. One night while Preston was at a bar in Rock Springs, Cassidy saved his life, and Preston felt forever in the outlaw's debt. He would defend many Wild Bunch members and attempted to negotiate a pardon for Cassidy.

Preston would meet Cassidy and other clients who didn't want to attract attention at the Boars Tusk, a jutting volcanic formation in the Red Desert. Although the *Salt Lake Tribune* accused him of being bought by the Wild Bunch, he called the allegations "rot." Later he would become Wyoming's attorney general.

29

Seemingly sailing through a sea of sagebrush, Steamboat Mountain rises out of the Red Desert of southwestern Wyoming. Kit Carson reputedly became disoriented near here and had to summit this butte to get his bearings. The lack of landmarks, bad water, and remoteness of the desert were all traits that made it an outlaw haven.

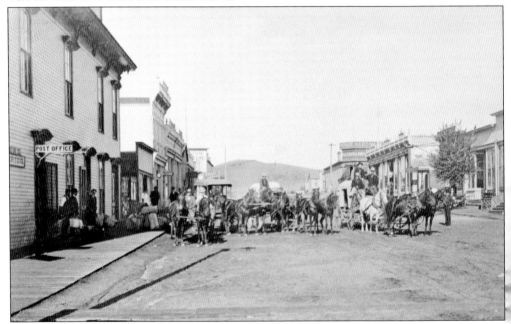

The citizenry of Rawlins, Wyoming, was largely split between those who worked for the Union Pacific Railroad and those who worked the range. Pinkerton detective Charlie Siringo wrote, "I arrived in the hurrah little city of Rawlins, where half the men are railroad employees and the other half, with the exception of the gamblers and saloon men, smell sheepy. Even the cattlemen get to smelling like sheep from the constant chasing of sheep off their ranges."

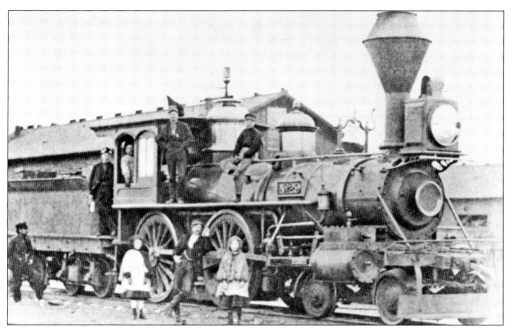

Like many newly formed communities, Rawlins had its share of tribulations with bandits. In June 1878, "Big Nose" George Parrott and "Dutch Charlie" Burris attempted to waylay the payroll car of a Union Pacific train by taking out the spikes from several railroad ties at a site outside town.

However, the outlaws' plans were thwarted when a section boss noticed the sabotage. They fled to the security of Rattlesnake Canyon near Elk Mountain (shown above), where they killed two pursuing lawmen, Tip Vincent and Ed Widdowfield. They were captured in Miles City, Montana, a year later.

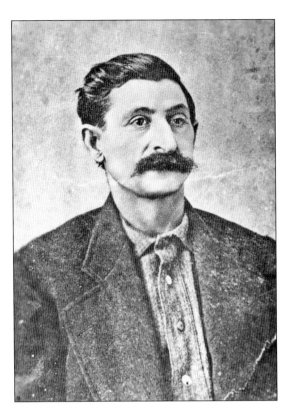

The killers were returned to Wyoming. Burris was forcefully taken from the train by a mob and hanged. Back in Rawlins, Parrott (left) was sentenced by Judge Jesse Knight to death. However, he was broken out of his cell by 200 vigilantes and hanged as a warning to other bad men.

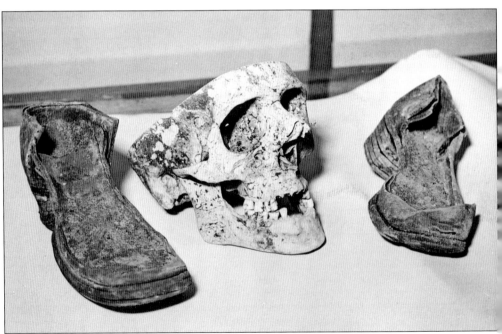

Drs. John Osborne and Thomas Maghee conducted experiments on Parrott's body. An ashtray was made from his skull, and his skin was used to make shoes that Osborne, later elected governor would wear to his gubernatorial ball. The skull and the shoes are on display in Rawlins.

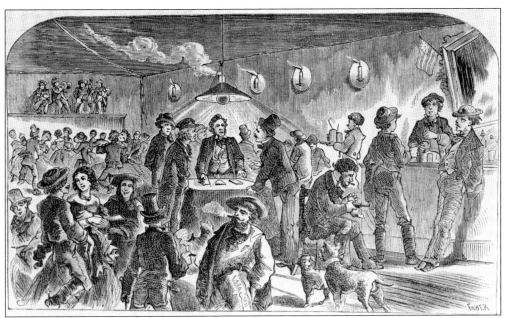

Located approximately 10 miles east of Rawlins was the "Hell on Wheels" town of Benton. Although the community only existed for three months in 1868, it boasted over 30 dance halls and saloons. The largest of the saloons was called "the Big Tent." As Zane Grey wrote, "it seemed a huge, glittering, magnificent monstrosity in that coarse, bare setting."

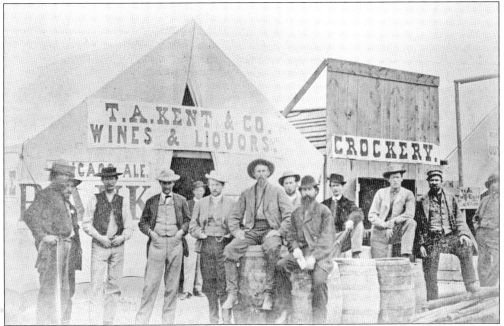

Jack Morrow was a bad man of southwestern Wyoming. A heavy drinker, braggart, and bully, he could easily be moved to violence. Here he is seen seated on a barrel (the figure on the left) at Benton. He sold hollow cords of wood and other false goods to the unwary. He would move to Omaha, Nebraska, where he became a county commissioner. (Courtesy of the Union Pacific Railroad Museum.)

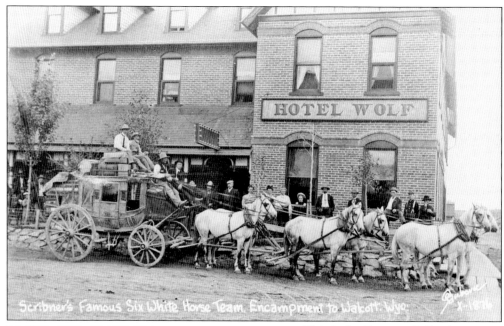

Scribner's Famous Six White Horse Team, Encampment to Walcott, Wyo.

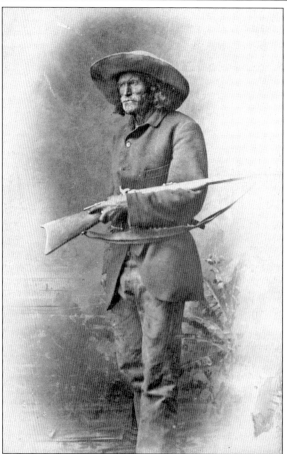

This is the Saratoga & Rawlins Stage Coach around 1900. Dan Parker, the younger brother of Butch Cassidy, robbed a coach similar to this near Rawlins in 1890. Since the bandit had robbed the mail, a federal offense, he was sentenced to life at the Detroit Penitentiary. His mother, Anne Parker, was able to secure him a pardon from President McKinley.

Jim Baker was one of the last true mountain men. Born in 1818, he was a friend of Jim Bridger and Kit Carson. In 1841, he, Henry Fraeb, and several trappers found themselves surrounded by Utes in the Sierra Madres. After a fierce encounter in which Fraeb and several Indians were killed, Baker and his colleagues retreated to safer territory.

Baker eventually settled in Baggs, Wyoming, in 1877 with two American Indian brides. He built this log house, where he would live until his death in 1898. Many folkloric stories about the mountain man abound in this town. He even had a run in with some local outlaws.

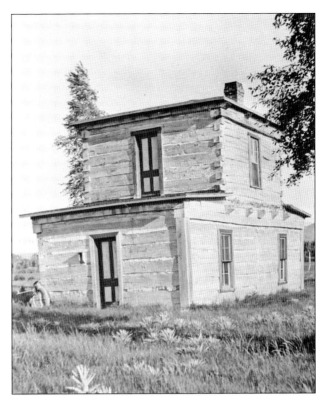

One night when Butch Cassidy and the Powder Springs Gang (as they were called locally) were celebrating in Baggs, a young outlaw decided to start trouble with Baker. Knowing that the greenhorn would be outmatched, Cassidy unsuccessfully tried to stop him. Before the youngster had time to draw his pistol, the mountain man brandished a tomahawk and chased the outlaw down the street to his colleagues' amusement.

As remembered by Warren Murphy in his book *On Sacred Ground*, Cassidy may have attended St. Luke's Church in Baggs. Roberta Toole, the wife of the minister, recalled seeing him, Elzy Lay, and another bandit there. "I was shaky, but I saw that they had a prayer book. They were very polite. One of the hymns was 'Rock of Ages' and all three sang lustily. They were generous with their offering and after the service shook hands with the Parson. . . . I was never afraid of them after that." This photograph is of the Baggs landscape that the Wild Bunch rode through.

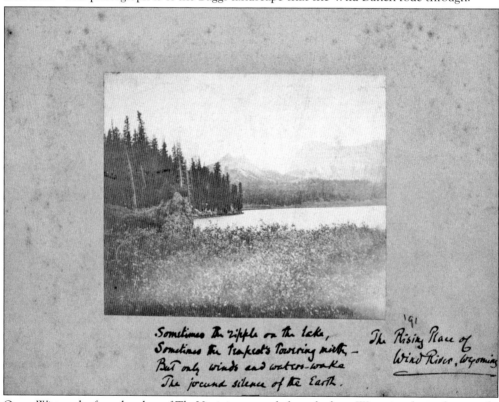

Owen Wister, the famed author of *The Virginian*, recorded much about Wyoming during his travels. Underneath this 1891 photograph of Brooks Lake is written a poem: "Sometimes the ripple on the lake, Sometimes the [illegible] towering mirth, But only winds and waters wake the jocund silence of the earth." The landscapes and communities of Fremont County in particular offered outlaws numerous hiding places.

Named after the adjacent passage through the Continental Divide discovered by Robert Stuart in 1812, South Pass City saw a gold boom in the late 1860s, with as many as 2,000 citizens gathering there in 1868. However, the "Sweetwater Fever" that gripped the area was short-lived. After the bust, the community persisted. The Outlaw Trail cut through here, making this a popular robber refuge.

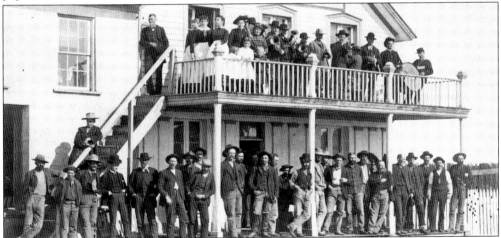

The community of Lander, Wyoming, had a curious mix of ranchers, miners, lawmen, and outlaws, many of whom gathered at the Lander Hotel. As an April 3, 1938, *Lander Journal* article describes: "One evening at dusk a weary traveler astride a sweat-covered roan, stopped at the old Nickerson barn in an alley back of the former location of the old Lander Hotel. As he was stretching his legs and wiping the grit from his weather-beaten face, Hank Boedeker, an old-timer and night marshal at Lander happened along. 'Howdy stranger, been travelin' some,' said the officer. 'Some,' said the stranger. Boedeker took a closer look at the pilgrim and exclaimed, 'Well I'll be damned if isn't Butch Cassidy; what'n hell are you doin' here? I heard you was dead.' 'Well, I ain't dead, an' I'm just goin' through and thought I would feed my hoss. . . . Be you still ridin' herd on the rowdies hereabouts, Hank?' "

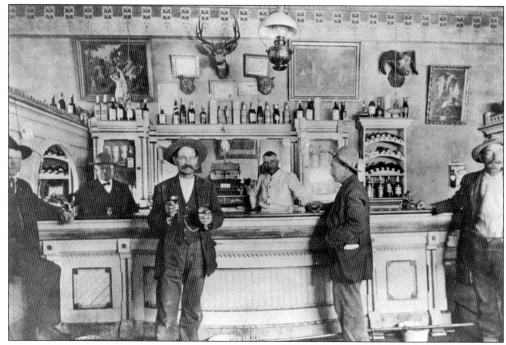

Grimmet's Free Silver Saloon of Lander, Wyoming, was a popular bar for lawmen. Jim Baldwin (center), a Fremont County deputy sheriff, was a friend of Butch Cassidy, although he tried to arrest him several times. He once claimed that "Butch Cassidy is the finest man I ever chased." Orson Grimmet (behind the bar to the left), the saloon's owner, was the Fremont County sheriff in the mid-1890s. He also admired Cassidy for his integrity and on more than one occasion tried to capture the elusive outlaw. This dualistic relationship between lawmen and outlaws was indicative of the complicated time.

Eugene Amoretti was a prominent businessman and at one point mayor of Lander. He was a friend of Butch Cassidy and owned several mercantiles, mines, and banks. Allegedly Cassidy once warned him of a planned robbery of his Lander bank by outlaws, thwarting the bandits' efforts. (Courtesy of the Wyoming State Archives.)

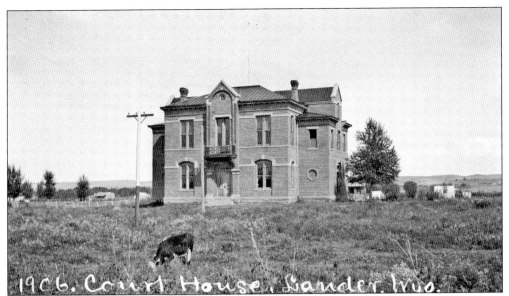

1906. Court House. Lander. Wyo.

Here is the old Fremont County Court House, site of Butch Cassidy's trial that would send him to the "Big House." In a May 5, 1939, letter to author Charles Kelly, Will Simpson, the former prosecuting attorney on the Cassidy case, wrote, "After Cassidy was sentenced to two years in the penitentiary he sent for me in the jail and told me that he did not blame me at all. That I had done my duty and that he wanted to be friendly. . . . At the time he was taken to the old Territorial Prison at Laramie City he made a request upon Charlie Stough, the sheriff, that he did not wish to be manicled with hand cuffs . . . and I know of my own knowledge that when Charlie went with him to the penitentiary that he didn't even have a gun on him."

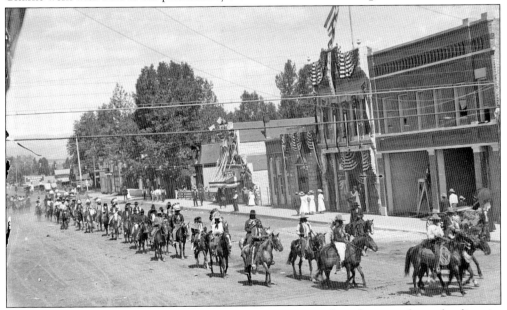

This parade in downtown Lander with Native Americans and cowboys speaks to the diversity of this community near the Wind River Reservation. The outlaws had many allies in "Indian country." The Native Americans and the outlaws both mistrusted the "blue coats" (the military), as well as other government agents.

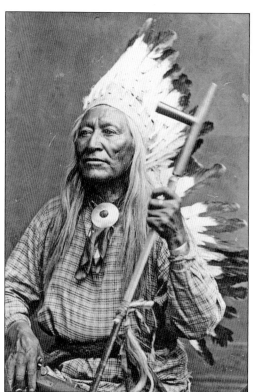

Born around 1800 to a Shoshone mother and a Flathead father, Chief Washakie was a fierce warrior and a savvy diplomat, defending his people's lands from the Crow, the Sioux, and the Arapaho. He negotiated the formation of the Wind River Reservation in 1878 with the US government.

Fort Washakie was the main trading post on the Wind River Reservation. Here is a store at the settlement in a photograph by the Owen Wister party. According to local lore, some of Butch Cassidy's colleagues tried to rob a mercantile here. Protective of the outlaw-friendly communities of Fort Washakie and Lander, the outlaw ordered the bandits to turn their steeds around.

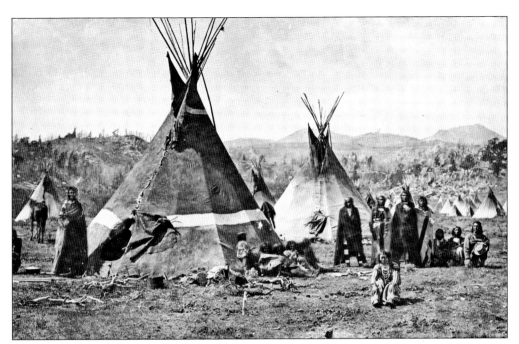

Here is Chief Washakie's camp on South Pass, a landscape set between the Red Desert and the Wind River Mountains. The Shoshone leader is standing in front of the light-colored tepee. The area was an important hunting ground to the Eastern Shoshone and a crossroads for travelers on the Oregon Trail.

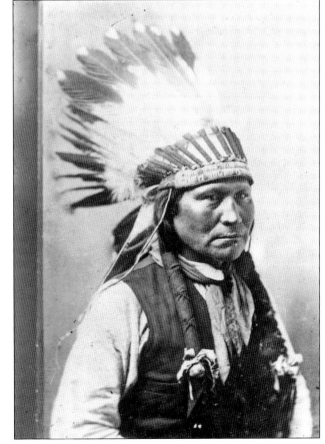

The Northern Arapaho people moved to the Wind River Reservation area in the 1870s. Their foremost leader was Chief Black Coal, famed for his fighting prowess and his political skills. A folkloric tale is still told that after Cassidy's incarceration, a group of Arapahos journeyed to Laramie, killing the prison guards and freeing the outlaw.

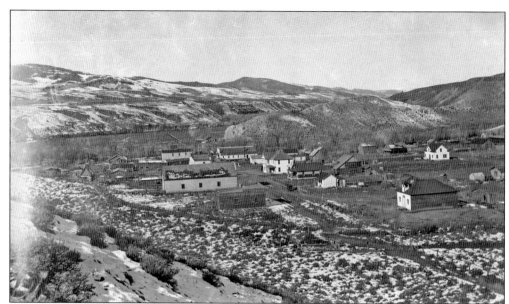

In the 1890s, Dubois was largely home to ranchers and tie-hacks. In 1889, Butch Cassidy, still known as George Cassidy, either bought or leased land on Horse Creek. The outlaw's friendship with neighboring rancher John Simpson and Cassidy's long ride to Fort Washakie and back to get medicine for Simpson's dying daughter have become local folklore.

Butch Cassidy and several friends are standing outside of Cassidy's ranch at Horse Creek. Eugene Amoretti Jr. is second from the left, and some identify Cassidy as the cowboy second from the right. Cassidy maintained the property with fellow rustler Al Hainer. Hainer later would be acquitted of the same horse theft incident that led to Cassidy's conviction.

Here is Dubois as it would have appeared in Cassidy's time. Wyoming historian A.F.C. Greene recounted one evening that Cassidy spent at the Simpson homestead when "Cassidy brought the spirit of frolic with him. . . . There are old-timers who tell to this day how the children shrieked with mirth and how Butch Cassidy set the pace, with his tow-colored hair in wild disorder and his puckered blue eyes blazing."

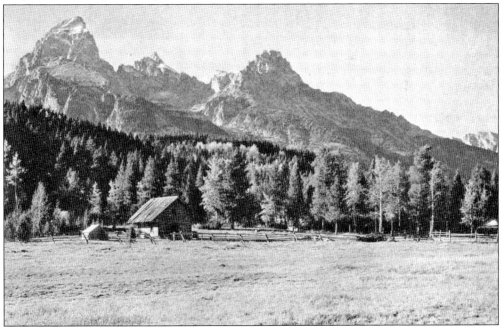

Cassidy's gang did occasionally visit Bert Charter, a former Wild Bunch member and Tipton robbery participant who had a ranch on Spring Gulch outside of Jackson, Wyoming. This photograph is of an area east of that site.

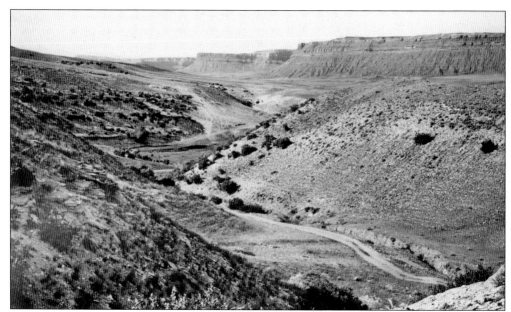

A rugged red-rock landscape nestled in the Bighorn Basin, Hole in the Wall was an unsavory place for lawmen to venture due to the risk of ambush. Some contend that Jesse James used it in 1877 to base his operations. The area was also used by "Big Nose" George in the 1880s and by Harvey Logan, "Flatnose" George Curry, and many Deadwood outlaws. (Courtesy of the Charles Kelly Collection, Utah State Historical Society.)

Butch Cassidy probably lived on a ranch in Hole in the Wall between 1890 and 1892 when he was a rustler and later may have used the landscape as his gang's hideout in the late 1890s. Cowboys are seen in an early-1900s photograph of "Hole in the Wall Sunday School."

Tensions in Hole in the Wall existed between its inhabitants since before the Johnson County War. Confusingly, there were many "Hole in the Wall Gangs." According to an August 19, 1897, *Wyoming Derrick* article, a group of cowboys "met with no serious encounter with rustlers, though war was threatened on two occasions." However, they "encountered signs posted up in the road making known to them that the rustlers were apprised of their movements."

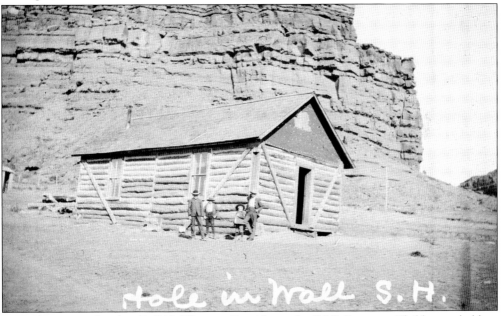

According to an October 7, 1897, *Wyoming Derrick* article, "U.S. Surveyor Glafcke was held up by the Hole-in-the-Wall gang while surveying in the mountains in Johnson County the first of the week, and robbed of camp, equipage, horses and everything he had." And in an April 28, 1897, *Cheyenne Daily Sun-Leader* article, a report is given of Deputy Sheriff William Dean being wounded in a firefight between lawmen and cattle rustlers. Afterwards, the sheriff dryly remarked, "What the Johnson County authorities need is a Gatling gun to clean out that 'Hole in the Wall gang.' "

Some believed that the depredations of the outlaws in Hole in the Wall were exaggerated. As one visiting Rawlins rancher noted in an April 16, 1898, *Buffalo Voice* article: " 'Why,' he remarked, 'the stuff I have [been] reading is a lot of unmitigated lies, and I am going to send word to the effect to the *Rawlins Journal.* . . . I have seen nothing to warrant the hair-raising stories of blood thirsty gangs that are sent out by the Casper and Cheyenne papers."

A bucolic scene is described in the September 9, 1897, *Wyoming Derrick* when Capt. George Smith and the Hole in the Wall Gang "rode into Coopersville . . . and challenged the dippers [sheep-herders] to a shooting match. The dippers accepted the challenge, to shoot 75 yards, free for all; entrance fee, 25 cts, winner to take the pot. At noon the honors were about equal, but after being refreshed by a square meal the rustlers became bolder and raised the entrance fee to $1.00. Needless to say, the rustlers were defeated, and . . . N.R. Gascho won the sheep laurel crown for being the crack shot of the day."

Set in the Bighorn Basin, Meeteetse had a history not unlike that of many Wyoming communities such as Buffalo and Kaycee of strife between the small ranchers and stock barons of the day. This image is of a cow camp during the wintertime. The community was notorious for being an oasis for outlaws.

The neighboring Absorakas and Big Horns provided ample hiding places for outlaws on the run. Some of these same bandits worked on local ranches, sometimes rustling cattle and horses from adjacent outfits. As historian Jim Blake states, "We rode the dark shadows of the community. In 1899, there was no law in Meeteetse."

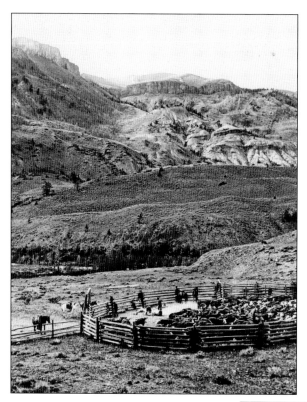

Meeteetse's Pitchfork Ranch was owned by the "Little Baron," Otto Franc, a powerful rancher, justice of the peace and Johnson County Invasion supporter. Franc was one of the men responsible for the conviction of Cassidy for horse theft. Franc would later die here under mysterious circumstances from a shotgun blast.

Col. Jay Torrey owned the Embar Ranch in an area between Thermopolis and Meeteetse. Butch Cassidy worked for him as a ranch hand. Torrey would play a key role in the Johnson County Invasion. He would also provide evidence to the prosecution in Cassidy's horse theft case, aiding in the bandit's conviction.

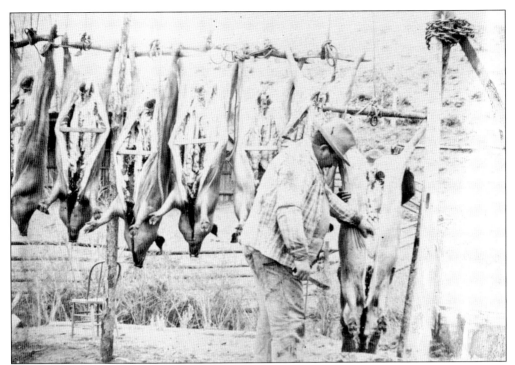

Ranch work was laborious and often dangerous. Here a ranch hand is gutting pigs on the Embar. Butch Cassidy worked at the ranch around the time that this photograph was taken in the early 1890s. An experienced horseman and rancher, Cassidy would have spent his time herding cattle and caring for livestock.

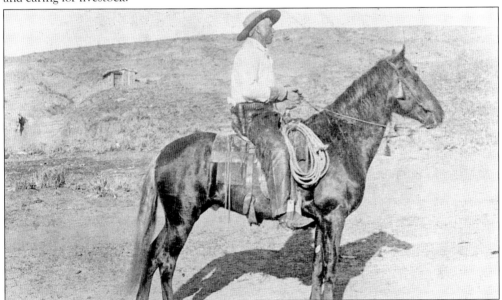

Billy Nutcher, a rustler, spent time in Meeteetse. He sold a stolen $5 horse to Cassidy. Wyoming law dictated that someone must knowingly buy stolen goods to be implicated in a crime. While it is not clear if Cassidy was aware of this, the incident would precipitate his eventual arrest and incarceration at the Wyoming State Prison.

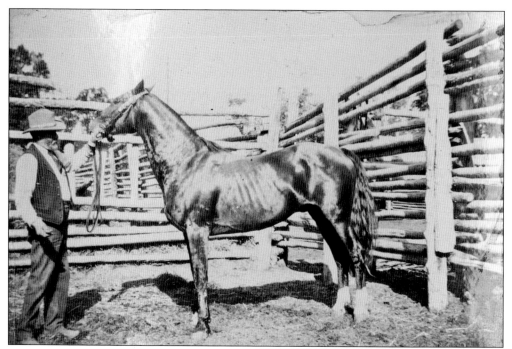

Here is a ranch hand on the Embar Ranch. The photograph may be of Jacob Price, a rustler and outlaw who served time at the Wyoming State Prison in Laramie and also rode with the Wild Bunch. Price would be involved in several disputes over cattle ownership with Embar managers.

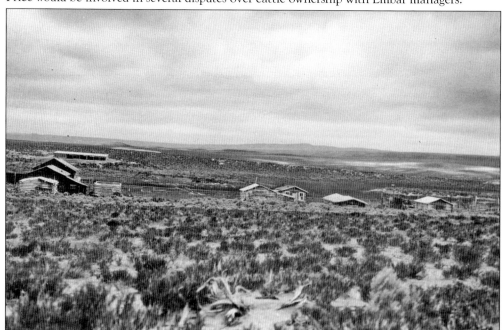

The Outlaw Trail meandered through the rolling sagebrush country of South Pass, by most credible accounts following the Oregon, California, and Mormon Pioneer Trails and the Pony Express Trail. Seen here is the Pacific Springs Ranch, located near a former Pony Express watering station. (Courtesy of the Charles Kelly Collection, Utah State Historical Society.)

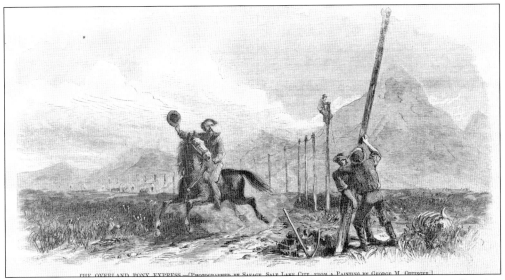

In this undated print, a Pony Express rider gallops past workers raising telegraph wires. Starting in 1860, the Pony Express rode from St. Joseph, Missouri, to Sacramento, California, with the promise of a 10-day delivery window. The first transcontinental telegraph line was erected in Wyoming in 1861, soon making the express obsolete. (Courtesy of the Library of Congress.)

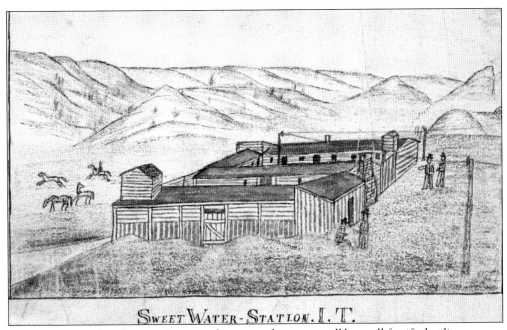

Some of the sites that the Pony Express riders stopped at were small but well-fortified military camps such as Sweetwater Station. These forts had been constructed during the military's campaigns between 1862 and 1867 to protect telegraph lines along the Oregon Trail from Indian raids. This 1863 drawing is by Bugler C. Moelman, a soldier with the 11th Ohio Cavalry.

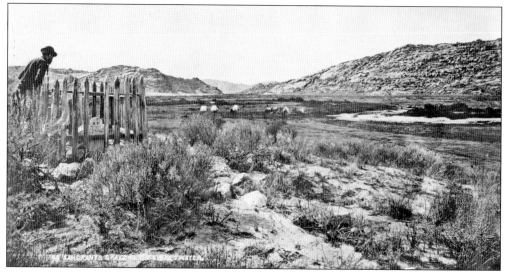

Outlaws traversing the Sweetwater country near the Rattlesnake Hills shared the land with Pony Express riders, emigrants on the Oregon Trail, and soldiers at Three Crossings Station (above) and Sweetwater Station. They would have had to be careful not to attract attention. The headstone at the left of the photograph is testament to the trail's hardships.

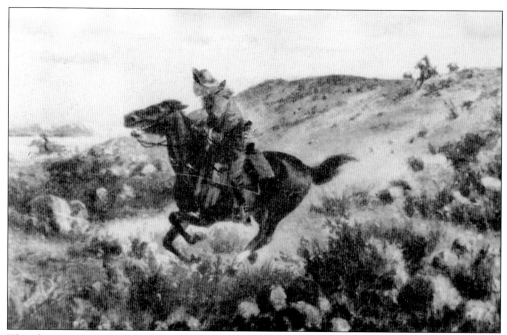

This drawing shows a Pony Express rider in full gallop across the Western landscape. Although not clear, it is likely that the horsemen in the background are Native Americans in hot pursuit.

Emigrants increased their use of the Overland Trail after "Indian troubles" of the early 1860s forced them southward. The Overland Trail's Granger Stage Stop near Green River was built in 1861 or 1862. Some of its more famous visitors included Mark Twain, Horace Greeley, and the photographer William Henry Jackson. It is immortalized in Twain's story *Roughing It*.

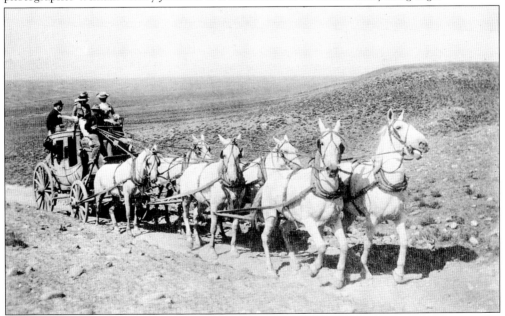

The Overland Trail was fraught with perils for the stagecoach riders, freighters, and pioneers who rode it. Highwaymen, Indians, the heat, and the hardship made travel dangerous. Ironically, one of the most unpredictable and violent men in this country was an Overland Express employee by the name of Jack Slade.

Slade was a friend of Wild Bill Hickok, who reputedly admired Slade's gumption when it came to dealing with highwaymen. After being ambushed by enemy Jules Beni—who nearly disemboweled Slade with a shotgun—Slade swore revenge. Miraculously recovering from his wounds, he found Beni a year later at a stage stop along the Colorado-Wyoming border. Slade reputedly shot his rival more than 20 times. After torturing his victim all day, he put Beni out of his misery. Slade cut off his victim's ears and wore them as gruesome souvenirs.

Jack Slade worked at the Virginia Dale Stage Stop of northern Colorado. He may have nailed one of Jules Beni's ears to a corral post here. Due in part to Slade's fearsome tactics, Overland Express robberies declined. He was also partially responsible for the clearing out of the lawless elements that inhabited the Colorado-Wyoming border country, an area locals referred to as "Robbers Roost." However, his erratic behavior would catch up to him. Although Slade would be exonerated for his numerous crimes, including Beni's death, he would go too far. In 1864, after shooting up an establishment in Virginia City, Colorado, he was reprimanded by Sheriff J.M. Fox and jailed. In court, Slade drew a derringer and threatened Judge Alexander Davis. A crowd of more than 600 outraged citizens hanged the weeping killer, even after Davis pleaded with them to spare him. (Courtesy of the Denver Archives.)

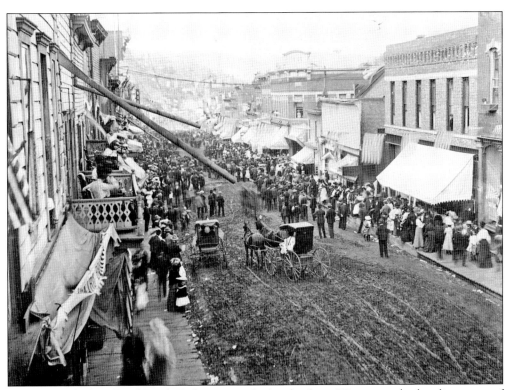

Set in the Black Hills of South Dakota over the border from Wyoming, the bustling town of Deadwood was a gold boom community where outlaws often took refuge thanks to its lawless ways. Butch Cassidy, the Sundance Kid, and the Curry Gang may have frequented it during the 1890s. (Courtesy of the Adams Museum.)

After Gen. George Armstrong Custer announced the discovery of gold in the Black Hills in 1874, the town was quickly flooded by prospectors, swelling its population to near 5,000. The community was known for its lawlessness, with numerous dens of iniquity, including opium parlors, saloons, and brothels. (Courtesy of the Library of Congress.)

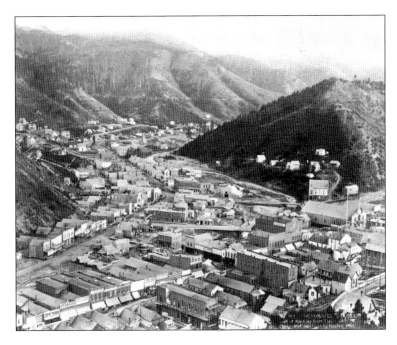

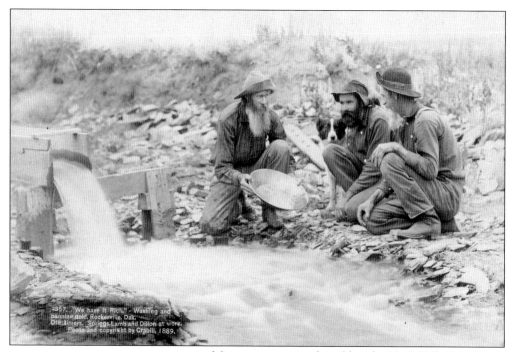

4357. "We have It Rich." - Washing and panning gold, Rockerville, Dak. Old timers, Spriggs, Lamb and Dillon at work. Photo and copyright by Grabill, 1889.

Miners are panning for gold in the Black Hills. Like South Pass City and other Western boomtowns, hundreds flocked to the community to gain easy riches. Although smaller mining efforts were eventually replaced by industrial mining, it did little to stem the tide of bonanza-dreaming prospectors. (Courtesy of the Library of Congress.)

On August 2, 1876, gunfighter Wild Bill Hickok was playing poker in a Deadwood saloon when he was shot in the back of the head by buffalo hunter Jack McCall. Although his true motive for killing Hickok is unknown, McCall may have been hired to assassinate Hickok by one of the lawman's enemies or he may have been avenging the death of a man he later identified in court as his brother, Lew McCall, who had been reputedly shot by Hickok. (Courtesy of the Adams Museum.)

Owned by Al Swearengen and frequented by Jack McCall, Seth Bullock, and other Western legends, the Gem was one of the most popular Deadwood bars. McCall was arrested for Hickok's murder but was acquitted by a citizens' court. McCall was again arrested in Laramie City, Wyoming, by lawman Nathaniel Boswell and returned to the Dakota Territory, where he was tried again, found guilty, and hanged. (Courtesy of the Adams Museum.)

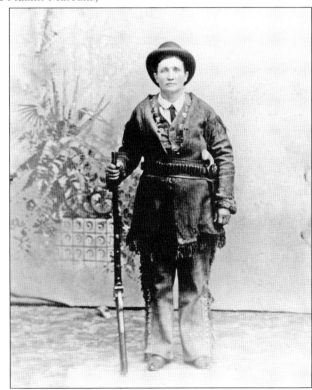

Martha Jane Canary, known as "Calamity Jane," was a former scout for Gen. George Armstrong Custer and a close compatriot of Wild Bill Hickok. The nature of her relationship with Hickok is still debated. Her grave can be found next to the gunfighter's headstone in Deadwood. (Courtesy of the Adams Museum.)

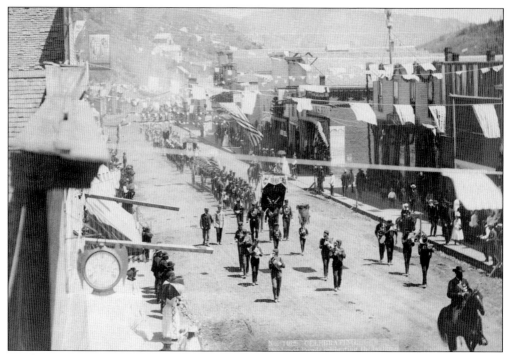

Deadwood citizens are celebrating the 1888 opening of the largest gold and silver reduction mine in the world. Although it was a rough frontier town, the fine clothing of some of the parade viewers indicates a level of refinement with some of its citizenry. (Courtesy of John Grabill, Library of Congress.)

This Wells Fargo Express Company's Deadwood Express stagecoach is carrying $250,000 in gold bullion. Several guards are on the ready for an attack by bandits. Such coaches along the Cheyenne-Deadwood Trail made tempting targets for highwaymen such as Wyoming's Clark Pelton, who preyed upon them. (Courtesy of the Library of Congress.)

Three

RIDERS OF THE OWL HOOT

Many of Wyoming's most successful outlaws were "social outlaws," bandits who relied on the people for shelter from their enemies. These men—Butch Cassidy, Elzy Lay, and the Sundance Kid among others—helped citizens pay mortgages; gave supplies, money, and gold to children and their parents; and visited "justice" on greedy bankers and landowners. Indeed, the social outlaws of the American West, along with the highwaymen of Europe and the bushrangers of Australia, are representative of a larger outlaw hero tradition that has existed since the Middle Ages. Dick Turpin and Robin Hood of Great Britain are prime examples of this tradition, which according to Dr. Graham Seal "consists of ten motifs or discrete but interacting narrative elements [that include]: friend of the poor, oppressed, forced into outlawry, brave, generous, courteous, does not indulge in unjustified violence, trickster, betrayed, lives on after death."

Quite wisely, bandits such as Cassidy avoided the violent fate of a common criminal (such as Wyoming's Big Nose George Parrott) or a sociopathic killer (such as Jack Slade) by concentrating robberies on railroads, banks, and mining companies, largely organizations that were construed as being predatory of the common populace.

However, not all of Wyoming's outlaws were of the Robin Hood mold or were Western outlaws in the stereotypical sense, riding through the sagebrush with Winchesters at the ready. For instance, William Nash was a 15-year-old boy incarcerated for forging a check. Lillie Todd was imprisoned for petty theft. Caroline Hayes was imprisoned once due to making a mistake at the wrong place at the wrong time. Young and old alike, men, women, and children, these citizens who lived beyond the law provide a diverse gallery of characters. Here are some of their stories.

Here is a disputed photograph of a young Butch Cassidy. Born on April 13, 1866, in Beaver, Utah, Robert LeRoy Parker was the eldest of 13 children. Seeing his family grow up in poverty may have contributed to the young Cassidy's decision to hit the Outlaw Trail. Robert would adopt the last name "Cassidy" from a Circleville, Utah, ranch hand, Mike Cassidy, who taught him how to ride, rope, and rustle.

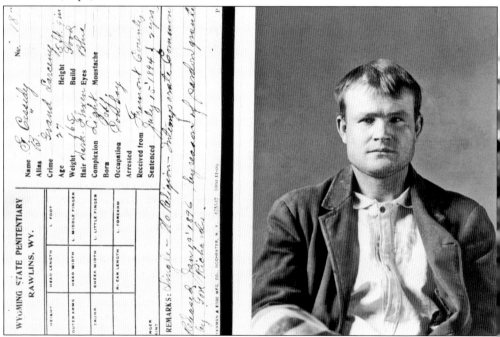

Butch Cassidy was incarcerated for buying a stolen horse. The judge who sentenced him, Jesse Knight, described him in an 1895 letter to Gov. William A. Richards: "Cassiday is a man that would be hard to describe—a brave, daring fellow and man well calculated to be a leader, and should his inclinations run that way, I do not doubt but that he would be capable of organizing and leading a lot of desperate men to desperate deeds." Pardoned by Richards, Cassidy would waste no time in forming the Wild Bunch. He probably adopted the nickname "Butch" from working in a Rock Springs butcher shop. (Courtesy of the Wyoming State Archives.)

Tom McCarty may have taught a young Butch Cassidy how to rob banks starting with a heist in Telluride, Colorado, but unlike Cassidy, he lacked compassion. Utah historian Pearl Baker quoted McCarty stating, "We never could have rode the owlhoot trail if it hadn't been for the ranchers and the stockmen liking us and helping us out. It was partly to their advantage to do that; ranches were a long way apart, and if a man didn't play along, he could have been killed and his ranch burned. At that time it would have been laid onto Indians." (Courtesy of the Utah State Historical Society.)

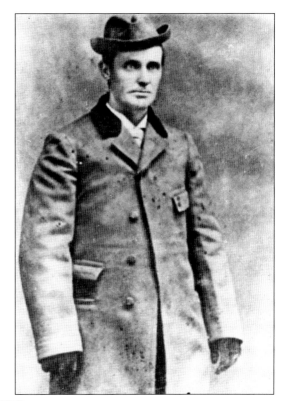

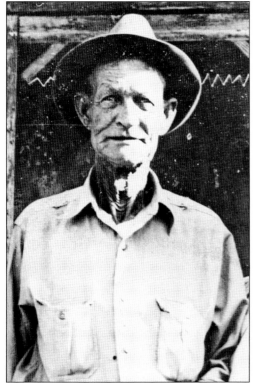

Dan Sinclair Parker was one of Butch Cassidy's brothers. Although Cassidy had tried to dissuade Parker from hitting the Outlaw Trail like him, Dan, under the alias of Tom Ricketts, robbed a mail coach on October 19, 1890, with William Brown near Muddy Station on the Dixon-to-Rawlins mail run. He was arrested in Moab, Utah, and tried in Cheyenne. Larry Pointer describes the incident in the book *In Search of Butch Cassidy*: "They were charged with 'robbing a mail carrier of the United States Mail' and for putting the life of the carrier in jeopardy in effecting such robbery by use of dangerous weapons." Dan was held at the Wyoming Territorial Prison in Laramie and then transferred to the Detroit House of Correction to serve a life sentence. Due to his family's repeated appeals, he received a pardon and was released in 1897.

Harvey Logan, also known as Kid Curry, and his girlfriend, Della Moore, appear in this undated photograph. Curry was known for his ruthlessness, killing at least 10 adversaries. At one point, he was arguably the most wanted outlaw next to Cassidy. Moore may have been a former prostitute from Fannie Porter's bordello in Fort Worth, Texas. His sobriquet, "Kid Curry," was an adoption of his mentor Flatnose George Curry's name. (Courtesy of the Charles Kelly Collection, Utah State Historical Society.)

Pike Landusky and his wife, Julia, sit in their home in Landusky, Montana, the town that he founded. Charles Kelly wrote that the miner, known for his temper, "had licked every man in that section of the west," even killing several with his hands. Kid Curry gained his enmity due to his rustling activities. On December 27, 1894, Curry and Landusky would square off in a local saloon. Landusky, finding himself outmatched by the younger man, pulled a pistol, which misfired. Curry drew a gun and killed him.

Harvey Logan (center) poses with his two brothers, Johnny (left) and Lonny (right). The Logan brothers were originally from Rowan County, Kentucky. They would join up with "Flatnose" George Curry, a rustler who was leader of the Curry Gang as well as the Hole in the Wall Gang for a period.

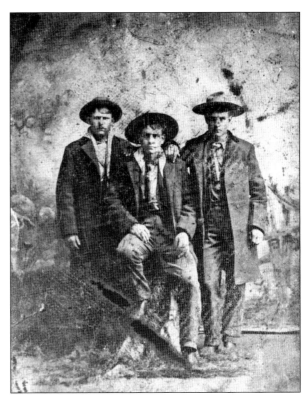

Shown below is a disputed photograph of the Wild Bunch outside the Bull Dog Saloon in Baggs, Wyoming, with Cassidy fourth from the left. This may be the same institution that Charles Kelly refers to in his book *The Outlaw Trail*: "Punctuating their requests for 'snake eye,' they shot twenty-five holes in the bar of the saloon and then to show no hard feelings gave the saloonkeeper a dollar for each hole to compensate him for damages."

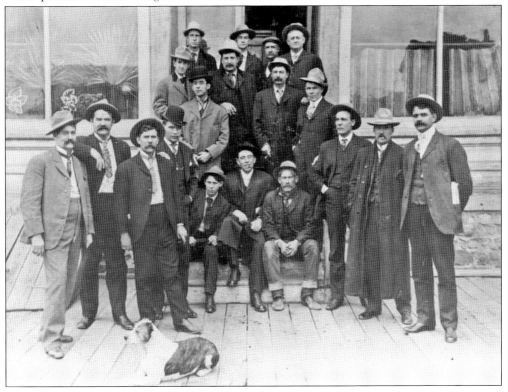

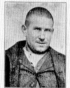

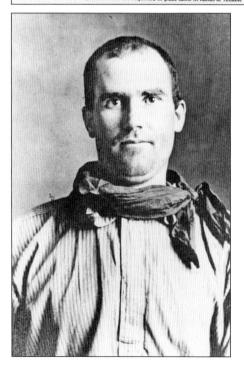

The Pinkertons distributed wanted posters for Butch Cassidy and his allies throughout the West. This particular one features Cassidy, the Sundance Kid, and Camillo Hanks. Hanks played a role in the robbery of a train in Wagner, Montana, on July 3, 1901, the last holdup credited to the Wild Bunch. (Courtesy of the Charles Kelly Collection, Utah State Historical Society.)

Henry Wilber "Bub" Meeks was a member of the Wild Bunch who successfully robbed the Montpelier, Idaho, bank on August 13, 1896, with Elzy Lay and Cassidy. He was incarcerated at the Idaho State Correctional Facility for his crime. Meeks would escape several times, the last attempt costing him his leg from a bullet. While at St. Alphonsus Hospital in Boise, Idaho, recovering from his injury, he tried to kill himself. He was transferred to an insane asylum, which he escaped from on a stolen horse. Although his family cared for him for several years, his mania necessitated transferring him to a hospital in Evanston, Wyoming, where he died in 1912.

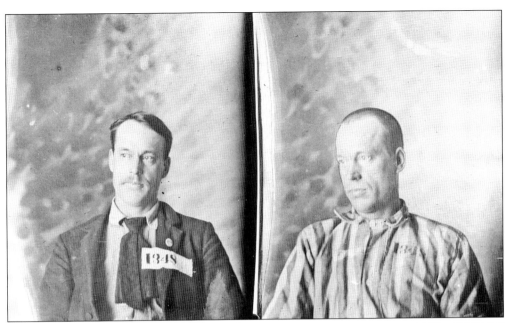

Elza (Elzy) Lay was one of the most educated men in the Wild Bunch. A strategist like Butch Cassidy, he was thought to have conceived some of the Wild Bunch's most celebrated robberies. He is best known for the Castlegate, Utah, payroll robbery. In this episode, he and Cassidy disguised themselves as jockeys and managed to pull off a daylight heist of the Pleasantville Mining Company surrounded by dozens of heavily armed miners. In 1899, Lay was charged with the murder of Sheriff Edward Farr and imprisoned. He was released in 1906 and became a geologist, working the Powder Wash country near Browns Park. He lived his final years in Southern California. (Courtesy of the Charles Kelly Collection, Utah State Historical Society.)

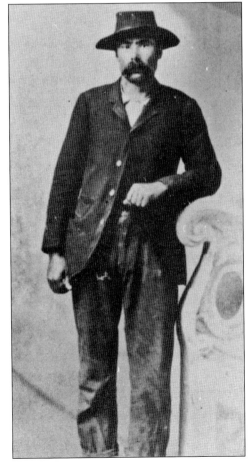

Tom O'Day was an outlaw in northern Wyoming. On June 28, 1897, he and several bandits—probably George Curry, Harvey Logan, Walt Puntenay, and the Sundance Kid—robbed the bank in Belle Fourche, South Dakota. However, his horse spooked from the gunfire, leaving him on foot. After taking refuge in a saloon, he was arrested. Although he would overpower the guard and escape, he would be recaptured along with several other gang members. Butch Cassidy reputedly financed his legal counsel, and he was acquitted.

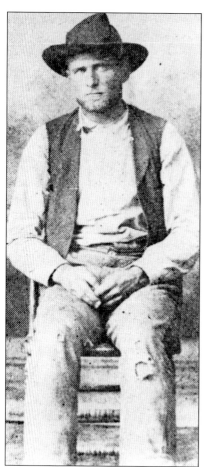

Walt Puntenay was a seasoned rustler and bank robber. He was one of the few Wild Bunchers besides Matt Warner and Elzy Lay to "go straight." In 1931, Puntenay opened up a saloon, the Cowboy Bar, in Pinedale, Wyoming, and lived his post-outlaw days in this idyllic community between the desert and the mountains.

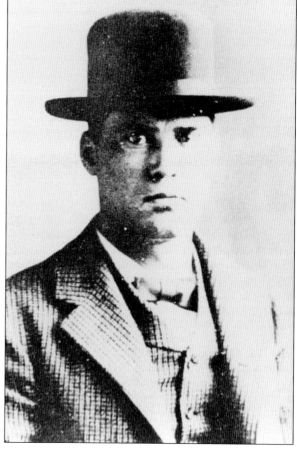

A cousin of Harvey Logan, Robert ("Bob") Lee was one of the few members of the Wild Bunch captured in the months following the Wilcox train robbery. He served time at the Wyoming State Prison in Laramie and at the Wyoming State Prison in Rawlins and was released in 1907. Lee was asked by Buffalo Bill Cody to join his circus and participate in a train robbery reenactment, although it is not known if he accepted the offer.

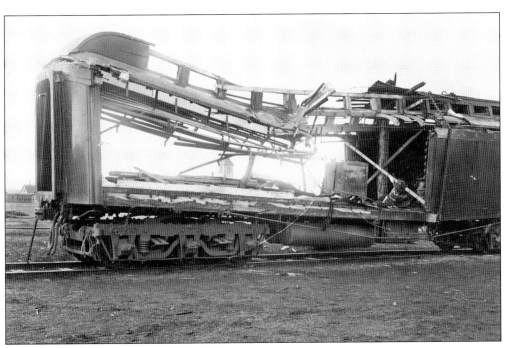

At around 2:00 a.m. on June 2, 1899, members of Butch Cassidy's Wild Bunch flagged down the Union Pacific's *Overland Flyer* near Wilcox, Wyoming. Using too much dynamite on the safe, they destroyed the baggage car and much of the train. However, no members of the crew were killed, and no passengers were injured. This is a photograph of the damaged express car.

The *Overland Flyer*'s safe shows signs of damage from the gang's dynamite. Approximately $50,000 was stolen during the robbery, money destined for American troops in the Spanish-American War. It was an embarrassing episode for the railroad and the US government. President McKinley took the incident seriously. As the June 14, 1899, *Rawlins Semi-Weekly Republican* reported, "Governor Richards has communicated with President McKinley and the Department of Justice at Washington has authorized United States Marshal Hadsell to take any steps to apprehend the bandits that the situation may demand."

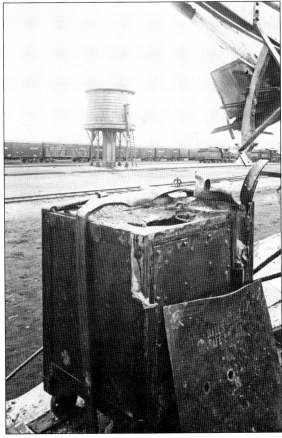

After the Wilcox robbery, the unsigned bank notes and, by some accounts, singed bills and bills stained by raspberry juice from a fruit crate were used by detectives to track down robbers. A new rubber stamp was thereafter used by banks on currency as a precautionary measure. Several posses were used to track the Wild Bunch, over 300 men in all, with bloodhounds brought by train from Beatrice, Nebraska. Many of the bandits were not tracked down for months, and Cassidy remained at large. (Courtesy of the Library of Congress.)

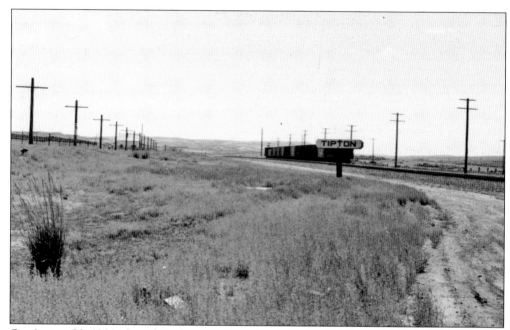

On August 29, 1900, Cassidy's gang struck again. A Union Pacific railroad car was robbed at Tipton, Wyoming, by masked gunmen. The September 11, 1900, *Wyoming Tribune* reported: "After the express car had been sacked by the robbers, the one who stood guard over Conductor Kerrigan asked 'What time is it?' Kerrigan pulled out his watch and said, 'I suppose you want this, too.' 'No,' answered the bandit. 'We don't want anything from the railroad boys.' Then a minute later the outlaws disappeared in the darkness with a genial 'Goodbye, boys.'" Although it is not known if Cassidy was at Tipton, the cheerful goodbye certainly had the trademark of the gentleman bandit. This photograph taken by outlaw historian Larry Pointer is of the Tipton train robbery site.

A posse is being transported to Rock Creek after the Tipton robbery. The Union Pacific Railroad in the years following the previous Wilcox robbery had increased security measures, designing specially made cars that could quickly transport lawmen and horses to crime scenes. The posse's horses are probably in an adjacent car.

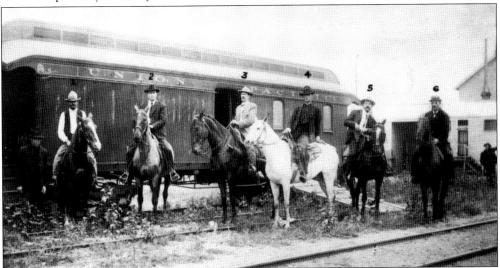

Here is one of several posses that set out to capture Cassidy's gang after the Tipton train robbery. Famed lawman Joe LeFors is the figure third from the left. However, unlike at Wilcox, the robbers had placed fresh horses at locations along the escape route. Again, Cassidy disappeared. Union Pacific officials asserted that the robbery was a failure. The press didn't believe them. According to the September 6, 1900, *Weekly Boomerang*, "the belief is brewing here that the five robbers who held up and looted an express car at Tipton Wednesday secured a greater amount of money then the trifling sum of $54."

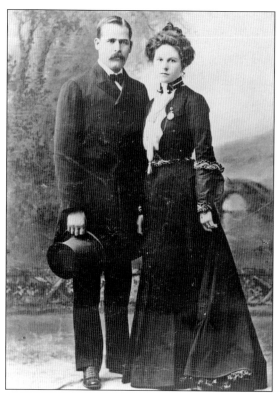

The Sundance Kid and Etta Place pose for a photograph in a New York City studio. The Sundance Kid (Harry Alonso Longabaugh) was a noted gunman and a member of the Wild Bunch's inner circle. Longabaugh, Place, and Cassidy sailed for Argentina from New York in 1901 after taking in the city's sights. While the Pinkertons were searching for them in the West, the trio thwarted their efforts by hiding in plain view in America's most populated metropolis.

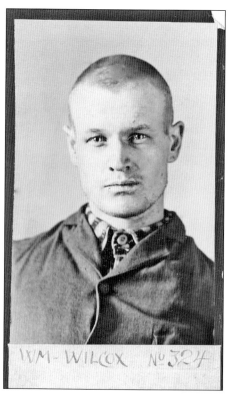

William Wilcox was jailed at the Wyoming Territorial Prison twice, once for burglary and once for forging a check. According to historian Elnora Frye, he buried a false mustache and duplicate keys in his cell, landing him in "the hole" for a five-day stint. According to Larry Pointer, it was here that the young Wilcox probably first met Butch Cassidy. (Courtesy of the Wyoming State Archives.)

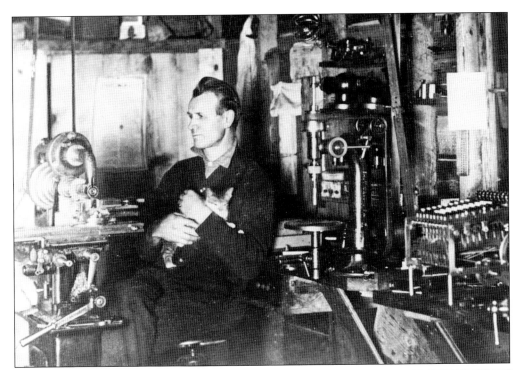

Wilcox may have joined Cassidy's gang after his release from prison in 1898. In later years, he went by the name William Phillips. Seen here in his machinist shop in Spokane, Washington, he would spend a large part of his life impersonating Butch Cassidy. He knew much about Cassidy's professional life and his personal life, even corresponding with the bandit's former paramour, Mary Boyd, in Fremont County, Wyoming.

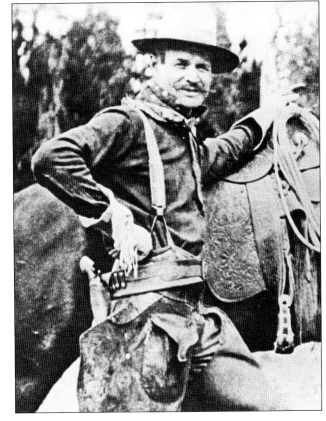

Phillips poses for a photograph in Big Horn Canyon. An adept marksman and rider, he returned to his old haunts in Wyoming on several occasions to look for the Wild Bunch's buried gold in the Wind River Mountains and visit many of Cassidy's friends. To many, it was as if Cassidy had returned.

Phillips was remembered by many as visiting Wyoming in an old car in the 1920s and 1930s. Sadly, he died of cancer in 1937, and his ashes were sprinkled on the Little Spokane River. His dream of publishing his manuscript, *The Bandit Invincible*, a story of Butch Cassidy's life, was never realized during his lifetime.

Red Cloud was a chief and war leader of the Oglala from 1868 to 1909. He waged successful campaigns against the US Army in the Powder River country of northeastern Wyoming and in southern Wyoming between 1866 and 1868 and secured a treaty with the US government in 1868 forming the Great Sioux Reservation. He was jailed in Casper, Wyoming, in 1885 for hunting without a license.

Clark Pelton, a stagecoach robber along the Cheyenne-Deadwood Stagecoach Trail, was incarcerated for two years in the prison in Laramie for killing a lawman in 1877. After his release, Pelton became a successful businessman, providing the timber for a new stockade built at the same institution that had previously held him.

Eliza "Big Jack" Stewart shot a man in the throat at a dance hall in Hanna, Wyoming, in January 1890, earning a two-year sentence at the Wyoming State Prison in Laramie. During her time there, she was confined in solitary quarters for quarreling with fellow convict Minnie Snyder. (Courtesy of the Wyoming State Archives.)

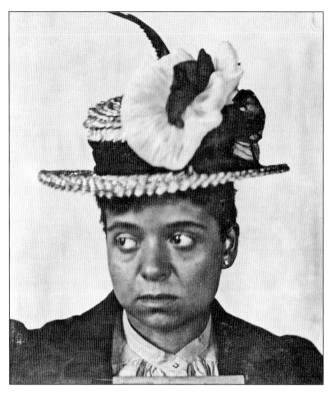

On August 6, 1900, Lillie Todd stole jewelry from a room at the Vendome Hotel in Cheyenne to support her morphine addiction as well as her husband's craving for the drug. Although it was probably her husband's idea to carry out the robbery, Todd was arrested at the train depot and later incarcerated. (Courtesy of the Wyoming State Archives.)

Annie Groves was sent to the Wyoming State Prison in Rawlins, Wyoming, in 1907 after attempting to kill James Passwater at Smizer's Saloon in Encampment, Wyoming. The man had infected her with syphilis and refused to pay her medical bills. She was pardoned and released early after her plight was known to authorities. (Courtesy of the Wyoming State Archives.)

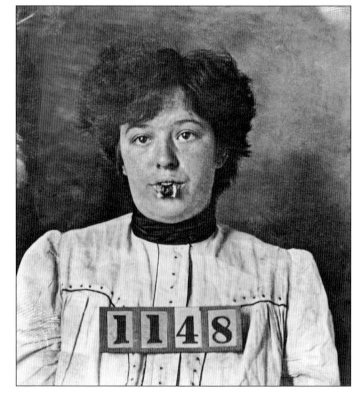

Pearl Smith (right) and a friend, Gertie Smith (below), along with two male compatriots, went on a stealing spree across Wyoming. In Rawlins, after a visit to the local saloon, they robbed a store, and after loading their pockets with merchandise, they proceeded back to their hotel room. However, Pearl, Gertie, and the other thieves drunkenly left a trail of dropped goods all the way back to the hotel, giving police a perfect path to follow. All four were imprisoned in the Wyoming State Prison in Rawlins. Pearl was transferred to the Wyoming State Prison in Laramie in 1902 for a short period before being pardoned and released early for good behavior. Gertie Smith was also pardoned and released early due to her failing health. Sadly, she died shortly thereafter during childbirth in Denver, Colorado.

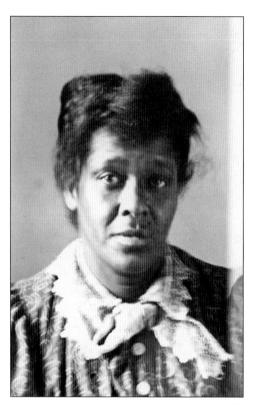

Caroline Hayes served time twice at the Wyoming State Prison. In 1896 and in 1897, she was admitted for a bizarre arson incident and for burglary. Shortly after her last release, she was held at the Albany County Jail for stealing two 50¢ blankets one winter. She later rejoined her family in Green River, Wyoming. (Courtesy of the Wyoming State Archives.)

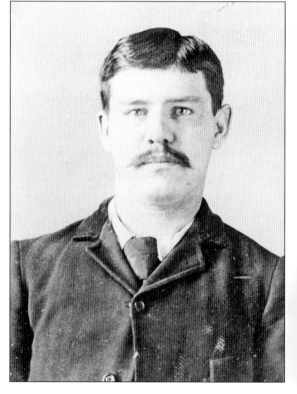

Lawrence Hereford, a rancher from Fort Bridger, Wyoming, was incarcerated at the Wyoming State Prison in 1891 after he killed James Maas, a man who had raped his sister. He was pardoned and released for good behavior after serving 10 years of a 20-year sentence. (Courtesy of the Wyoming State Archives.)

William Nash was incarcerated in 1897 for forging a $34.65 check. Although his intake paperwork indicated that he was 21, it is not likely that he was over 15 years of age. The young man spent much of his life in and out of jail for various offenses. (Courtesy of the Wyoming State Archives.)

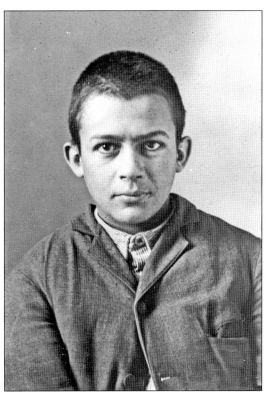

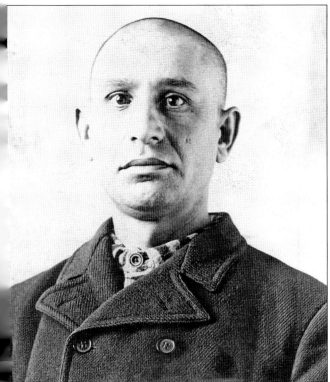

Julius Greenwald was a cigar maker who had a proclivity for frequenting bordellos. On August 2, 1897, he found his wife, Jennie, working in an Evanston brothel and shot her. Serving several years at the Wyoming State Prison in Laramie, he helped the warden build a lucrative cigar making business. He died of heart failure. His ghost still reputedly haunts the prison's corridors. (Courtesy of the Wyoming State Archives.)

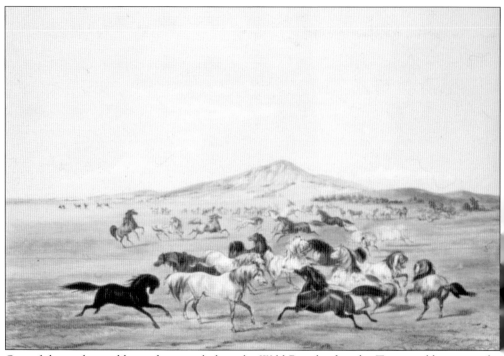

One of the tricks used by outlaws, including the Wild Bunch after the Tipton robbery, was the use of wild horses to confuse trackers. A July 7, 1908, *Laramie Republican* article recounts: "They had stampeded a herd of horses, and riding in the midst of the animals, hoped thus to effectually throw their pursuers off the scent. . . . [However] one, who had been an Indian scout easily picked out the footprints."

Outlaws hid messages for each other in hollow tree trunks, in rocky crevices, and "on top of round mounds in the desert," according to detective Charlie Siringo. He recalls that this "system of blind post offices [ran] all the way from Hole in the Wall in northern Wyoming to Alma in southern New Mexico. . . . In passing these post offices . . . members of the Wild Bunch, who were on the inside would look for mail . . . deposited in the post office by passing members."

Knowing where the best water was in their backcountry peregrinations, outlaws frequently had an advantage over their pursuers. Streams, seeps, and ponds were essential for survival. Matt Warner remembers that outlaws erected signs reading "poison" at springs to confuse pursuing posses. The lawmen frequently turned back.

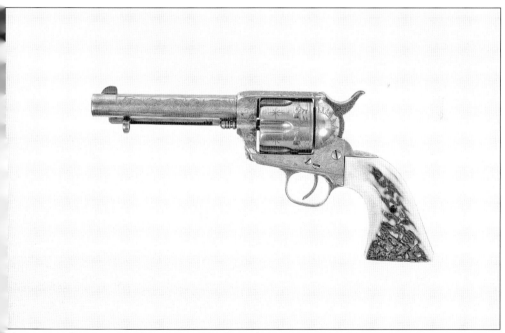

The 1871 Colt Army Revolver was used by the military until 1892. It was one of the favored pistols of Western ranchers, outlaws, and gunmen. As former Wild Buncher Matt Warner remembers, "He can shoot straighter and faster with a single-action six shooter. We used to practice what's called fanning. . . . It was the nearest thing we had in them days to a machine gun." (Courtesy of Brian and Anne McDonald, Buffalo Bill Historical Center.)

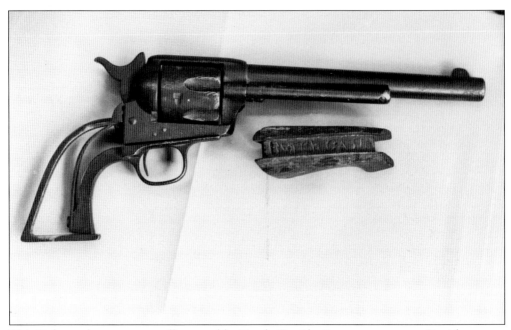

This Colt revolver was reputedly owned by Butch Cassidy. By some accounts, Cassidy was an excellent marksman, although he rarely used his pistol during holdups. As is remembered by Larry Pointer, "Parker would take 13-year old Fred . . . over the hill and put on dazzling displays of shooting. Spurring his horse along the fence, he alternately shot at the fence posts, first with his pistol in his right hand, then his left, never missing a post."

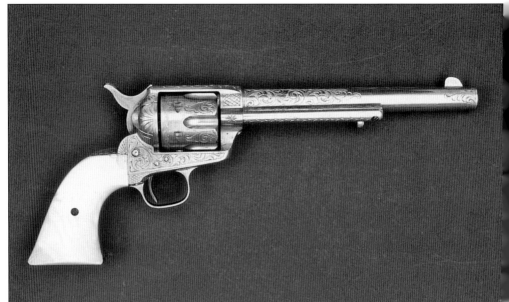

The Colt 1873 Frontier Single Action Army Revolver was also known as the "Peacemaker" due to its effectiveness in resolving disputes. Accurate and affordable, it replaced the cap and ball guns that preceded it. With superior stopping power to newer revolvers, it was used by lawmen and soldiers well into the late 1890s, including Teddy Roosevelt in his charge up San Juan Hill. (Courtesy of the Lilian E. Herring Collection, Buffalo Bill Historical Center.)

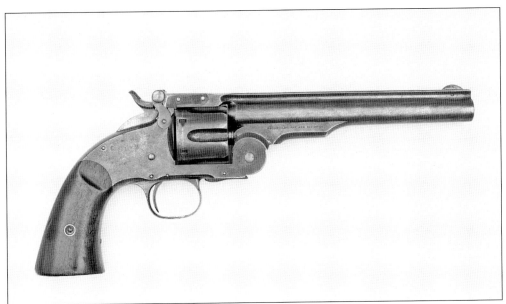

The .45 Schofield revolver was developed in 1875 as an alternate to the popular 1871 Colt .45. It was one of the more popular guns with outlaws and Western "bad men," including Jesse James. Produced between 1875 and 1915, it was a sturdy pistol that held up well under tough conditions in the field. "A pistol is nothing but a man-killing weapon, a murder machine," wrote Matt Warner. "When a man practices with one like I practiced, he has just one idea in his head and one kind of feeling. He is practicing to make an expert man-killer of himself."

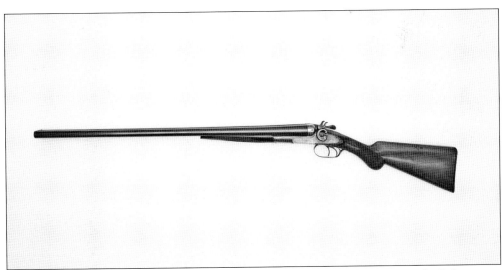

The shotgun was a favorite gun of lawmen, stagecoach guards, and prison guards. Delivering a wallop at close range, it could be fired quickly and fairly effectively at numerous targets. This is a Model 1889 Remington shotgun, a popular weapon during the outlaw era. (Courtesy of William Furnish, Buffalo Bill Historical Center.)

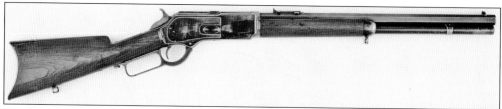

The Winchester Model 1873 rifle was used by many pioneers, outlaws, and lawmen during the settling of the frontier, earning it the affectionate title "the Gun that Won the West." The company produced over 700,000 of these rifles, making them affordable and available. (Courtesy of Olin Corp., Winchester Arms Collection, Buffalo Bill Historical Center.)

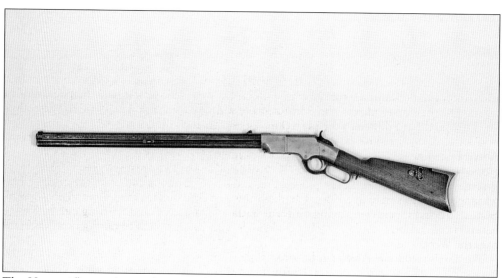

The Henry rifle was designed in 1860 by Benjamin Tyler Henry and used in the Indian Wars. An excellent saddle gun, it could fire more than a dozen rounds per minute, making it deadly in the hands of a skilled marksman. (Courtesy of Merle N. Taylor, Winchester Arms Collection, Buffalo Bill Historical Center.)

Four

POLITICOS AND LAWMEN OF OUTLAW COUNTRY

During Wyoming's settlement in the 1880s and 1890s, the primary powers of the time included the Union Pacific Railroad, the Wyoming Stock Growers Association, and the politicians in federal and state governments who worked closely with these entities. The Pinkerton detectives and lawmen did the difficult work of tracking, arresting, and killing outlaws.

The Pinkerton Detective Agency, whose operatives included the legendary Tom Horn, worked closely with these entities. The line between the outlaws and some of the lawmen was a thin one. Horn, who assassinated citizens with a .30-.30 for blood money, once reputedly said, "Killing is my specialty. I look at it as a business proposition, and I think I have a corner on the market." Not all range detectives were like Horn. Charlie Siringo tracked outlaws from Montana to Mexico. Systematic and inventive, playing different outlaw "characters" and handing out "reference letters" from "robbers" to shore up his credentials with bandits, he infiltrated groups' ranks all over the West.

The outlaws, like the American Indians before them, were perceived as a major threat to the continued settlement and taming of the American West. The Pinkertons, the Stock Growers, the railroads, and the government would wage a concerted war on them. As the September 18, 1900, *Saratoga Sun* reported regarding the Wilcox train robbery, "Money without limit has since been spent and is still being used in running every man to cover. . . . Not a man will finally escape, though the pursuit be kept up for twenty years."

Frank Canton was a range detective for the Wyoming Stock Growers Association and was Johnson County sheriff in 1882 and 1884. Like Tom Horn, he assassinated reputed rustlers, including most famously John Tisdale. The day before Canton died in 1927, he said, "I never shot a man in the back. I never shot a man while he was asleep. I never shot a man at all unless he was either shooting at me, or just ready too. And I always sleep well."

Originally from Memphis, Tennessee, Tom Horn ran away from home at a young age and headed west. In the 1880s, he worked for the US Army as a scout in the Southwest, helping negotiate Geronimo's surrender. In the 1890s, Horn was hired as a range detective for the Stock Growers, eradicating the lawless element. He fell from the grace of his employers after reputedly killing Willie Nickell, the son of a sheep rancher. He is seen here in his Cheyenne jail cell fashioning a lariat. He was hanged on November 20, 1903, a day before his 43rd birthday.

In the early hours of July 18, 1901, Willie Nickell was shot with a .30-.30 rifle, Horn's trademark murder weapon. Wearing his father's coat in the twilight, it is possible that Horn mistook the young Nickell for his intended victim. However, others believe that Horn knew too much about the Stock Growers' inner operations and had outlived his usefulness. Someone who knew Horn's methods may have framed him. In this pictured, Horn is seen talking to Glendolene M. Kimmell, an Iron Mountain school teacher he may have been romantically involved with.

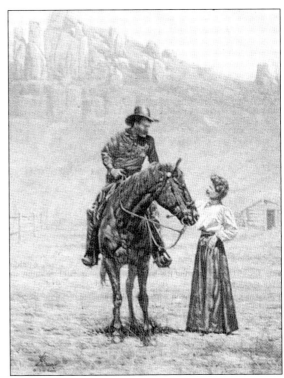

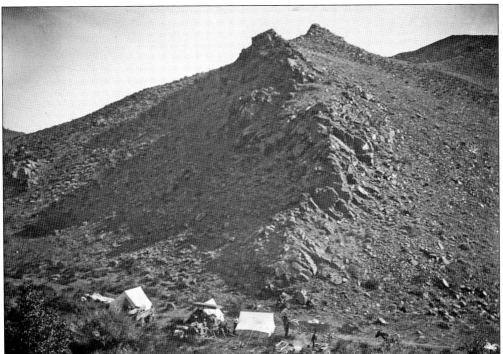

Although Horn's confession had been taken by his former colleague and friend Joe LeFors while Horn was drunk, and much evidence was not given to the jury, many believe that Horn was guilty. The scene of the crime on Iron Mountain is still visited by citizens, his case still debated.

Nathaniel K. Boswell was a famous Albany County lawman, US Marshal, and later warden of the Wyoming Territorial Prison in Laramie. Formerly a range detective for the Stock Growers, Boswell resigned his post prior to the Johnson County War, fearful that the stockmen would go too far in their war against the rustlers. Some believe that he may have been a member of the "vigilance committee" in Laramie City that illegally hanged members of the Asa Moore Gang.

Described by Dean Krakel, US Marshal Joe LeFors "feared neither man nor beast. . . . He dared to go to Hole in the Wall, a fortress of thieves. . . . He was a tireless tracker of law breakers, once in pursuit he seldom gave up the chase. His courage of steel, combined with a sense of fairplay won him the respect of all." LeFors is most famous for extracting Tom Horn's confession and for tracking Cassidy after the Tipton train robbery.

Charlie Siringo was a Pinkerton who tracked Butch Cassidy and Kid Curry by horseback over tens of thousands of miles. Siringo frequently adopted different personas and infiltrated desperados' bands from Texas to Wyoming. Although he helped incarcerate numerous vigilantes, he never did manage to capture the leaders of the Wild Bunch. The range rider in this photograph is similar in appearance to Siringo, who was known as the "Cowboy Detective."

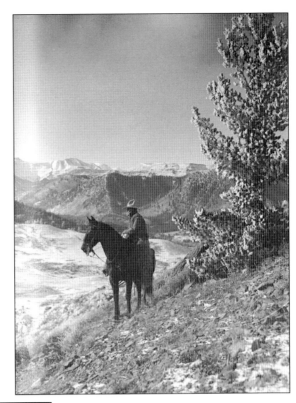

Originally from Lake County, Ohio, Sheriff Tom Whitmore of Sweetwater County, Wyoming, was a former Civil War veteran who had served with some distinction for the 142nd Illinois Infantry. Known for his valor, he helped restore order to Rock Springs during the aftermath of the Chinese Massacre. (Courtesy Sweetwater County Historical Association.)

Founded in 1862, the Union Pacific Railroad was one of the major industrial powers of its time and one of the main entities responsible for the settling of the American West. Outlaws who threatened the Union Pacific or thwarted the company's plans to continue its westward expansion were seen not only as enemies of the railroad but, by extension, as enemies of the state.

Although the landscapes of Wyoming still appeared to be wild and free, the open spaces through which the outlaws traveled were largely illusory. Railroads and other corporate entities were bringing rapid change to the state. The change visited upon the West's landscapes and communities was not always welcome with residents.

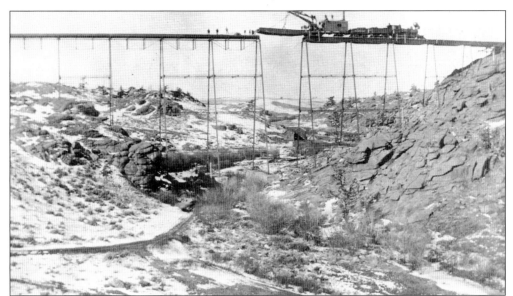

Completed in 1868, Union Pacific's Dale Creek Bridge in southeastern Wyoming was one of the most ambitious projects of its time. Social outlaws, bandits like Butch Cassidy and Elzy Lay who relied on networks of support to succeed, took advantage of the residents' wariness of change, waging a war against the railroads and their allies.

The Union Pacific hired some of the most talented boosters of the day, exhorting the landscapes and communities of the American West. This promotional poster displays iconic Western scenery and wildlife. Such advertising was essential to attract possible investors in the company as well as prospective pioneers to the frontier.

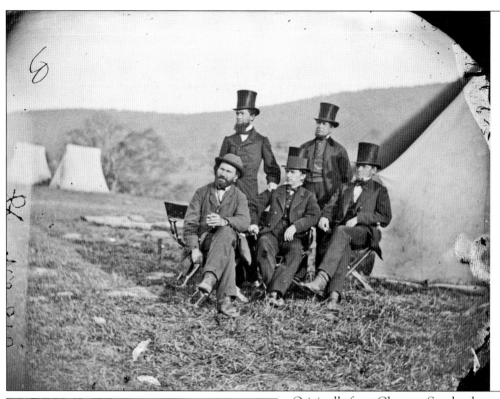

Originally from Glasgow, Scotland, Allan Pinkerton founded the Pinkerton Detective Agency, an intelligence unit that was initially formed to spy on the Confederates during the Civil War and provide protection for Pres. Abraham Lincoln. In later years, the agency acted as the arm of the government's allies, the corporations, in strike-breaking and intimidating labor groups. Pinkerton is seated here (front row, left) with other detectives. (Courtesy of the Library of Congress.)

Pinkerton stands with President Lincoln and an unidentified general at Antietam, Maryland. The "Pinkertons," as his detectives were called, expanded their operations throughout the United States and were hired by the Union Pacific Railroad to track down train robbers. Often called the "bulldogs of the U.P.," they were feared. (Courtesy of the Library of Congress.)

The "Seeing Eye" was the official logo of the Pinkerton Detective Agency. From it originates the term "private eye." It is possibly derived from a Masonic symbol. Although it is not clear if Allan Pinkerton was a Mason, many prominent men of his political and ethnic background were. (Courtesy of the Pinkerton Security Agency.)

E.H. Harriman was the director and later president of the Union Pacific Railroad. He waged a concerted war against the outlaws who threatened his company's security. He hired the elite Pinkertons to root out Butch Cassidy's Wild Bunch, other train robbers, and their allies. (Courtesy of the Library of Congress.)

Senators John Kendrick (center) and Joseph Carey (right) walk towards the Wyoming Capitol in Cheyenne. Carey was a powerful ally of the Wyoming Stock Growers Association and the Union Pacific Railroad, helping them in the campaign against the smaller ranchers, rustlers, and outlaws. He would later become governor of the state in 1918.

The US Army established forts over much of the West and ensured that supply lines, stage routes, and telegraph lines remained protected from outlaws and Indians. Soldiers' presence throughout the territory greatly hindered gangs' operations. Here is a photograph of the US Cavalry A unit outside of Fort Washakie, Wyoming.

Amos E. Barber, the second governor of the state of Wyoming, was a powerful ally of the Wyoming Stock Growers Association. Although he probably knew of the stockmen's infamous 1892 Johnson County Invasion, which plunged northern Wyoming into anarchy, he later denied all foreknowledge. (Courtesy of the Wyoming State Archives.)

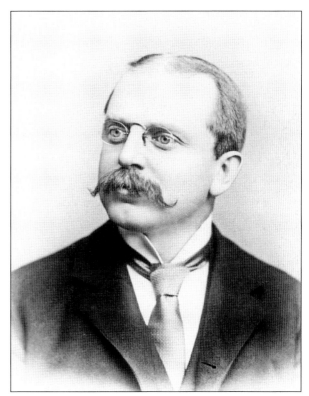

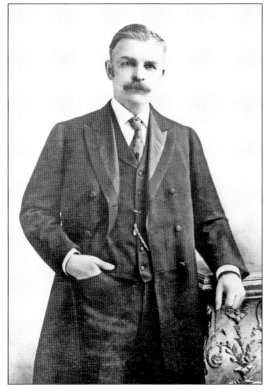

William A. Richards was the fourth governor of Wyoming. In an October 21, 1895, letter to Judge Jesse Knight regarding a prospective pardon for Butch Cassidy, he writes, "I have known something of . . . the circumstances and possibilities of the case of George Cassidy. The only question in this matter, in my judgment, is whether or not he will do what he is expected to do if released. My conclusion is that it is worth trying." The pardon did not have its intended effect. Cassidy formed the Wild Bunch after his release. (Courtesy of the Wyoming State Archives.)

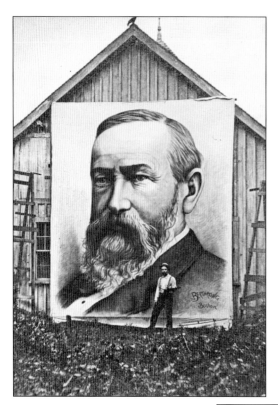

Pres. Benjamin Harrison (as depicted on a roadside poster) was asked by Wyoming governor Barber to send a cavalry unit to save the Johnson County Invaders. He and other presidents of his era were allies of the Stock Growers, the railroads, and the banks, ever mindful of the need to control Western lawbreakers. (Courtesy of the Library of Congress.)

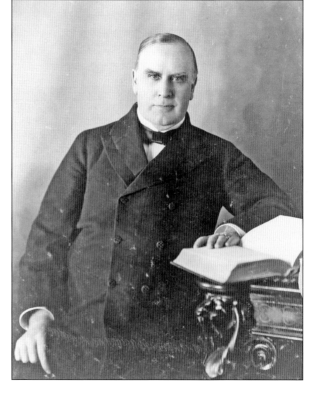

Pres. William McKinley declared war on Cassidy following the Wilcox train robbery. Cassidy had the temerity to steal money destined for paying American troops fighting in the Spanish-American War. McKinley authorized the State Department to use "all available means" to track down the Wild Bunch. (Courtesy of the Library of Congress.)

Five

The End of the Outlaw Trail

For most of its riders, the end of the Outlaw Trail was neither romantic nor glorious. As a September 18, 1900, *Saratoga Sun* article summarized:

> One year ago on Friday, May 31 the Wilcox train robbery on the Union Pacific took place, and in celebration of its anniversary, the Union Pacific officials are felicitating themselves that the Union Pacific proves a tough railroad for train robbers to tackle. . . . The result to the rash adventurers upon that raid are these: Louis Logan, alias Frank Miller, alias Lonny Logan, alias Lonny Curry, lies under the sod at Dodson, Mo., where, February 28, he came to a full stop while resisting arrest; George Curry, alias Flatnose George, occupies a lot in a cemetery, owing to that he resisted arrest April 17 at a point seventy miles north of Green River station, Wyo., while pursued, and Bob Lee, alias Bob Harris, alias Bob Curry, went to the Laramie penitentiary, in celebration of the anniversary, to serve a ten years' sentence imposed by the federal court.

Some outlaws, like Tap Duncan, died fighting ferociously, while others, like Jack Slade, left the world with a whimper. For Wyoming's "bad men," if death did not find them through a lawman's bullet, an enemy's knife, or a hangman's noose, a lengthy incarceration in a jail cell might await. For lucky ones who slipped over the border to Mexico or South America, freedom was assured. Few were so lucky.

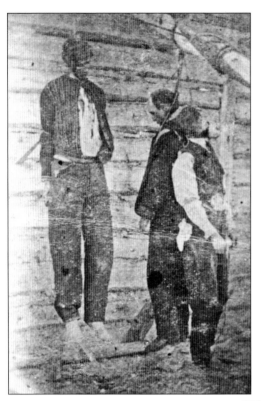

In 1868, Laramie City was a dangerous community, with citizens frequently being killed by thugs. Three roughs, "Big Ed" Wilson, Con Wager, and Asa Moore, who were implicated in a number of killings, were captured by vigilantes after a prolonged gunfight. Wilson (left) reputedly asked that he die without his boots on. He is seen swinging from the gallows in his stockings.

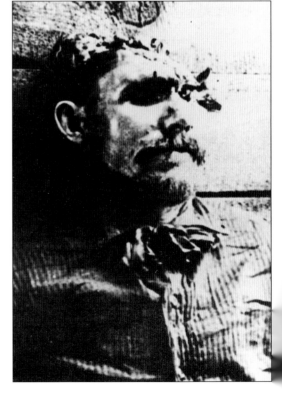

After a failed holdup of a bank in Delta, Colorado, on September 6, 1893, Tom McCarty, his brother Bill McCarty, and Bill's son Fred fled. Ray Simpson, a hardware store owner, shot Bill McCarty with a Sharps buffalo rifle, removing the top of the robber's head. He also quickly dispatched Fred McCarty. Tom McCarty galloped on, disappearing from the public eye.

"Flatnose" George Curry was caught rustling cattle by a ranch manager near Price, Utah, in 1900. After swimming the Green River and engaging in a shootout with the rancher, he was shot by a lawman who surprised him. His body was packed on ice and sent back to Chadron, Nebraska, for burial. (Courtesy of the Utah State Historical Society.)

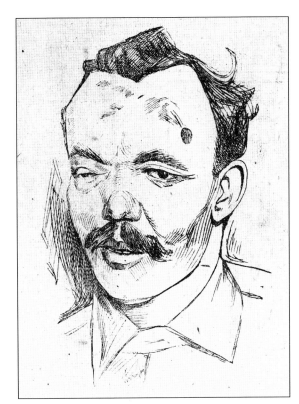

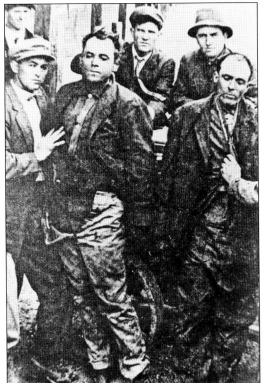

Originally from Coleman County, Texas, Ben Kilpatrick, the "Tall Texan," first rode with outlaw "Black Jack" Ketchum and later with Cassidy. Long after the Wild Bunch dissolved, he continued to rob trains. On March 12, 1912, he and another outlaw robbed the Southern Pacific near Dryden, Texas. While Kilpatrick was in the baggage compartment, a messenger grabbed an ice mallet and killed him. He is seen here in death (left).

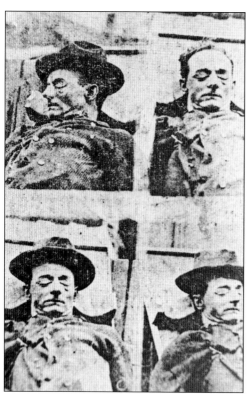

In June of 1904, several outlaws unsuccessfully attempted to rob a train near Parachute, Colorado. One bandit, after a fierce standoff with the posse, committed suicide. Many lawmen believed the man was the infamous Kid Curry. According to Larry Pointer's research, one detective found an envelope in the dead man's pocket written to "Tap Duncan." To this day, the dead man's identity in this photograph is debated.

After "Big Nose" George Parrott's body was experimented upon by doctors in Rawlins, his body was unceremoniously deposited in a whisky barrel and buried in an unmarked grave. His remains were discovered in 1950 during the construction of the First National Bank in Rawlins.

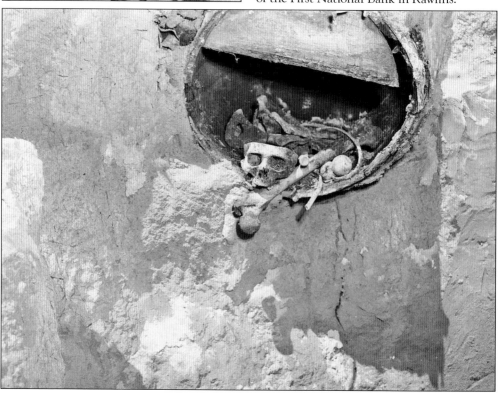

The Wyoming Territorial Prison (also the Wyoming State Prison in later years) in Laramie housed more than 1,000 prisoners between 1872 and 1903. Adhering to rules established by the Auburn Prison System, the prisoners were not allowed to talk to each other. Breaking this rule or others could lead to confinement in solitary.

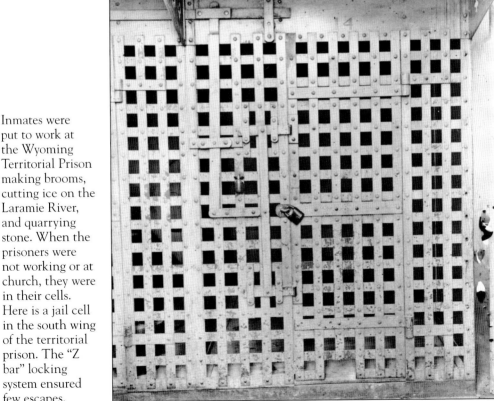

Inmates were put to work at the Wyoming Territorial Prison making brooms, cutting ice on the Laramie River, and quarrying stone. When the prisoners were not working or at church, they were in their cells. Here is a jail cell in the south wing of the territorial prison. The "Z bar" locking system ensured few escapes.

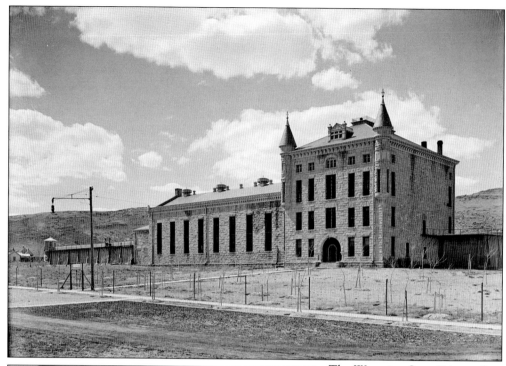

The Wyoming State Prison of Rawlins opened in December 1901 and replaced the aging Laramie prison. This institution housed more than 13,500 convicts. Fourteen prisoners were put to death here. Nine were hanged, and five were gassed. The prison was active until 1985.

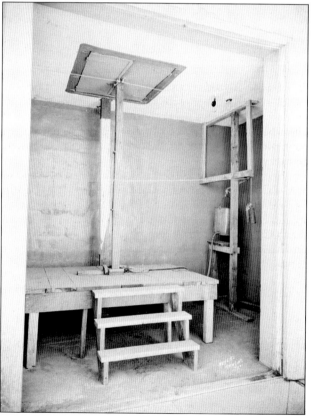

This particular type of gallows at the Wyoming State Prison in Rawlins was called the "Julian gallows." Prisoners would kill themselves. By stepping onto the trap door, the convict would set in motion a stream of water which would eventually spring the door, dropping him through the floor, breaking his neck. Tom Horn was hanged using such a device.

Six

THE STRANGE, SAD SAGA
OF EARL DURAND

Although the last of the horseback outlaws perished by the early- to mid-1900s, a book on Wyoming's Outlaw Trail would be remiss without a mention of Earl Durand. Born in 1913, the young David Earl Durand grew up outside of Powell, Wyoming, in the community of Garland. His parents were farmers who grew sugar beets and soy beans. However, Earl preferred to spend his time hunting and hiking in the mountains, avoiding chores. When he was back at his parents' house, he would sleep in a tent in the backyard.

He was a bit of an anachronism, a young man who emulated the mountain men of old. Jerred Metz in his book *The Last Eleven Days of Earl Durand* quotes a March 27, 1939, *Time* magazine article that asserted, "something of a joke in the country around Powell, Wyoming was huge, shaggy Earl Durand. From boyhood up, Earl Durand talked about wanting to be a true 'woodsman,' a 'Daniel Boone.'" He also idolized Butch Cassidy and Kid Curry.

Many locals in the 1930s viewed him as a Robin Hood–like figure, poaching elk in the vicinity and feeding poor families. However, he was imprisoned after one poaching incident. After breaking out of his cell, Durand was found by two lawmen, Chuck Lewis and D.M. Baker, at the Durands' farm. Durand shot them. Packing a rucksack, he grabbed some weapons and disappeared into the night. The saga had begun.

This photograph of Earl Durand was taken by one of his neighbors, Alfred Richardson, in Garland, Wyoming. It was distributed to police and media during the manhunt. An excellent marksman and outdoorsman who knew the backcountry of Park County thoroughly, Durand proved a dangerous adversary for his pursuers. (Courtesy of the Park County Archives.)

Park County prosecutor Oliver Steadman initially deputized 10 men to form a posse to hunt Durand. Here are several posse members outside Jim Owens's cabin on the Clarks Fork. Sheriff Blackburn had spoken to Durand's parents before the mission. However, they did not know their son's whereabouts and could not help. Having no choice, he ordered the hunt to begin. (Courtesy of the Park County Archives.)

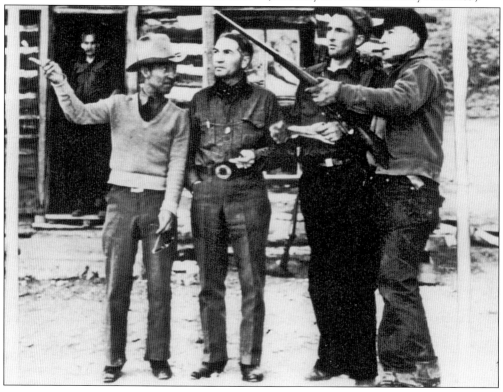

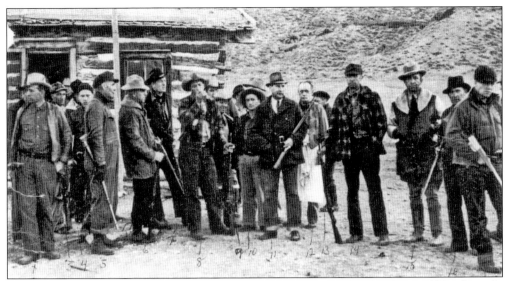

Men came from all over Wyoming to join the operation. Heavily armed and with several bloodhounds, they took to the hills. Since the outlaw was wearing rubber overshoes, the dogs couldn't find his trail, although trackers eventually picked it up. Several sharpshooters joined the company after a near ambush, a prelude of things to come. (Courtesy of the Park County Archives.)

Hiding behind a boulder, Durand shot two rangers, Orville Linabary and Arthur Agento. In the photograph above, several men can be seen recovering their bodies. One of the posse members holds a laceless boot, an item that would play into the saga. It was now clear to Blackburn that more help was needed. (Courtesy of the Park County Archives.)

The Casper Tribune-Herald

FINAL EDITION

"The Newspaper that Makes All Central Wyoming Neighbors"

48th Year—No. 29. Associated Press Leased Wire Service Casper, Wyoming, Friday, March 24, 1939. Ten Pages—Price 5 Cents

Brass Tacks — Pointed Comment, Serious and Otherwise on Late News Developments.

DURAND HOLDS OFF POSSE, DROPS TWO MEN IN TRACKS

State Basketball Tournament Swings Into Second Round of Competition

Bold Attempt to Reach Killer Costs Two Lives; Sharpshooters Plan Attack from Rear Today

Trench Mortar and Other Equipment Flown from Train Here; Montana Governor Sends Howitzer

CODY, Wyo., March 23.—(AP)—A heavy trench mortar, dynamite and gas bombs were rushed by airplane into northwestern Wyoming today in an attempt to blast Earl Durand, 26-year-old "Tarzan," from a rocky fortress where he held more than 100 men at bay all night after shooting down two possemen who attempted to rush his hideout.

CASPER BEATS LOVELL QUINT

Green River Is Next Opponent

Missing: Mrs. Eudora Cunningham (above).

HITLER GREETS MEMEL AS PART OF THE REICH

Declares Work of Reparation Has Been Completed "in the Main," Declares No Power on Earth Can Conquer Germany

MEMEL, March 23.—(AP)—Adolf Hitler concluded an eight-hour visit to this Baltic port, latest addition to his expanding realm when he departed at 4 p. m. (8 a. m., M. S. T.) today aboard the torpedo-boat Leopard for an undisclosed destination.

MURPHY FAVORS MERIT SYSTEM

Seeking Changes in Court Setup

Flier Picks Up

FLASHES OF LIFE

TheNational

Durand's murderous exploits were picked up by the press. A March 24, 1939, *Casper Tribune-Herald* article above displays headlines about Durand's murder of his two pursuers. The article reads in part, "Bold Attempt to Reach Killer Costs Two Lives; Sharpshooters Plan Attack from Rear Today." (Courtesy of the Homesteader Museum.)

Although Sheriff Blackburn continued the hunt, he asked federal authorities to aid him. While he was making these arrangements, he received a threatening letter from Durand that ended with the thought, "Of course I know that I am done for and when you kill me I suggest you have my head mounted and hang it up in the court house for the sake of law and order." (Courtesy of the Homesteader Museum.)

My Dear Mr Blackburn,

That was one dirty trick for you to jail those 2 boys just because I got away. If you send them over the road I will kill you and that blankety blank district attorney if I live long enough and possibly can.

Tell King and Kennedy to always carry a pistol. If I ever meet them I will give them a chance for an even draw, something I wont give you if you put up those boys.

Tell that man whose hay I killed that if I live long enough to get back in the mts. that he has nothing to fear from me, I hope I never see him again.

When you get after me better take about 20 men, for your body guard and put braces on their knees.

Of course I know that I am done for and when you kill me I suggest you hang my head mounted and hang it up in the court house for the sake of law and order. Your beloved enemy

Earl Durand

104

WESTERN UNION

1217-A

CHECK

ACCT'G INFMN.

TIME FILED

R. B. WHITE
PRESIDENT

NEWCOMB CARLTON
CHAIRMAN OF THE BOARD

J. C. WILLEVER
FIRST VICE-PRESIDENT

Send the following message, subject to the terms on back hereof, which are hereby agreed to

Cody Wyoming
March 23 1939

General Craig
Washington D C

Advise immediately whether three inch trench mortar available from
Fort Warren Wyoming stop Have two men available from Cody with
ROTC training to operate

Frank Blackburn
Sheriff Park County Wyoming

A March 23 telegram is seen here from Sheriff Blackburn to US Army Chief of Staff Malin Craig in Washington, DC, requesting the use of artillery in the search for the wary Earl Durand. With military weaponry now ordered, open war had been declared on the poacher turned killer. (Courtesy of the Homesteader Museum.)

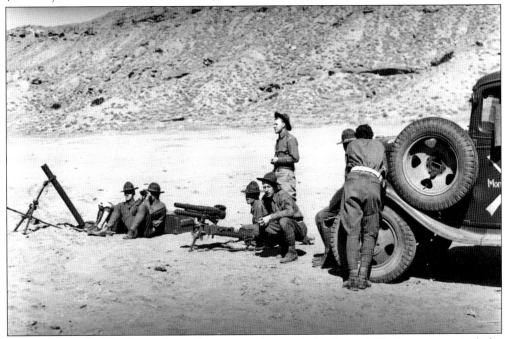

National Guardsmen prepare themselves to join the search for Durand. Their weaponry includes a mortar and a 37-milimeter anti-tank gun. Their demeanor is extraordinarily relaxed for the duty they have been called to fill. They would soon join local posses in the manhunt. (Courtesy of the Park County Archives.)

Earl Hayner, a citizen, glasses the mountains for a view of the elusive killer. With hundreds of citizens, lawmen, US Forest Service rangers, national guards, and FBI agents joining in the pursuit, reporters described the situation as being akin to a circus. (Courtesy of the Jack Richard Photo Collection, Buffalo Bill Historical Center.)

Bill Monday (left) and H. Evans are handling a 37-milimeter tear-gas gun next to Monday's plane. Monday's plane had been specially fitted with dynamite bombs to drop on the outlaw. From mortars to machine guns, the range of weaponry used in the operation was staggering. (Courtesy of the Park County Archives.)

A member of Blackburn's posse rests before another day's hunt. Ironically, while hundreds of men were looking for him in the backcountry, Durand managed to hijack a car and travel into town, securing more arms and ammunition. He then robbed the First National Bank of Powell. Some surmise he was carrying out a suicide mission. (Courtesy of the Park County Archives.)

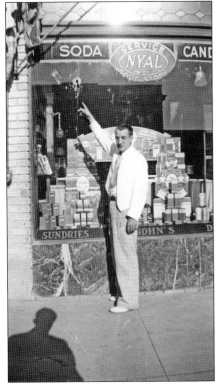

Jerred Metz quotes a March 29 *Cody Enterprise* article that describes Durand's behavior during the robbery: "Laughing, shouting, cursing he shot up the inside of the bank, then shot out windows and into the shop windows along Main Street." After taking money from the vault, Durand took several citizens hostage, trussed their hands using a dead ranger's bootlace, and marched them out of the building. Several shots were fired from bystanders. One from an unidentified citizen killed a hostage, and another from teenager Tipton Cox hit Durand in the chest. The robber lurched back into the bank and shot himself. This photograph shows where a bullet has found its mark from the shootout. (Courtesy of the Park County Archives.)

Earl Durand, in a style reminiscent of Kid Curry, had finally gone out in a blaze of glory. The above photograph of his corpse was taken shortly after the shootout. His body was later dressed in a suit and put on display at Easton's Funeral Parlor in Powell. (Courtesy of the Homesteader Museum.)

Hundreds of curious citizens gathered around the bank during and after Durand's standoff. Even after he had shot himself, citizens were still shooting at the building, unaware that the outlaw was already dead. In all, five residents had been killed in 11 days and hundreds more traumatized. (Courtesy of the Park County Archives.)

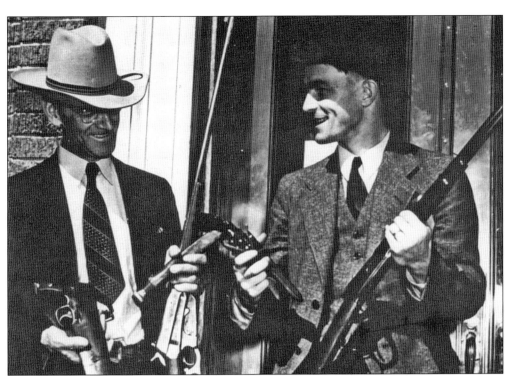

Sheriff Blackburn (left) and county prosecutor Steadman hold some of Durand's captured weapons for reporters' benefit. Within the assembled arsenal are two Winchester rifles, two handguns, and a knife. Although some historians question whether these were actually Durand's weapons, the outlaw had stolen several firearms from murdered rangers. (Courtesy of the Park County Archives.)

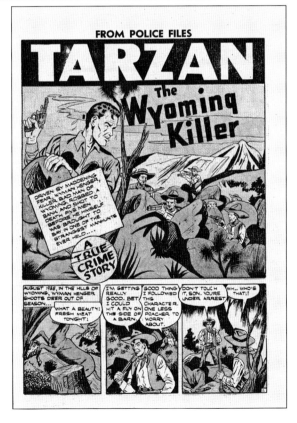

A *Famous Crimes* comic book page features a colorful version of the Earl Durand saga using a fictional character. Papers had dubbed Earl Durand the "Tarzan of the Tetons." The Tarzan image may have been partially perpetuated by Durand's hunting prowess and his fondness for raw elk meat. (Courtesy of the Homesteader Museum.)

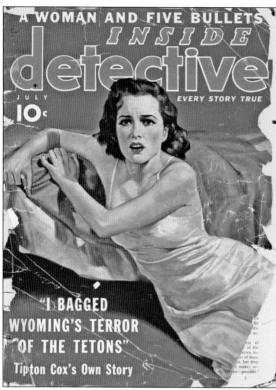

Inside Detective's front cover touts the Durand saga. Other pulp stories followed in the drama's wake, and eventually several films would be released outlining those memorable days. The "Terror of the Tetons" had indeed been bagged like a hunted animal. The scars of the incident would be felt by many for years. (Courtesy of the Homesteader Museum.)

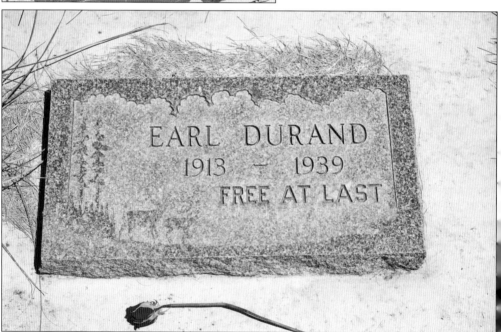

Earl Durand was buried at a gravesite in Powell. The young outlaw who had idolized Butch Cassidy and Kid Curry had left the world. To this day, his story, his character, and the bizarre, terrible events of his last 11 days are still a source of controversy in the Park County community. (Author's Collection.)

Seven

THE CHANGING WEST

The outlaws of the American West will always be inextricably linked with a physical landscape of aridity and rugged topography, of vast distances and wilderness. Former Wild Buncher Matt Warner suggests that he and others were displaced cowboys, individuals formed by the geography of the Western landscape, willing to fight and die for it and for its vanishing way of life. This notion was also echoed by Ed Kirby in his book *The Saga of Butch Cassidy and the Wild Bunch*, wherein he suggested that Cassidy and his counterparts hit the Outlaw Trail precisely because the way of life they had known was disappearing and they had no choice but to fight against those they deemed responsible for its demise: the big banks, the railroads, and the Stock Growers' associations.

By attacking these enemies of what they viewed as their land and people, Cassidy and the Wild Bunch not only made themselves "social outlaws" popular with segments of the populace but also declared themselves enemies of train and telegraph, baron, banker, and broker. Cassidy and those like him enlarged their battle to one that protected, in their eyes, a vanishing physical and cultural landscape.

However, it was a losing battle. The lands that had helped form these men were disappearing quickly. The forests were logged. Open spaces were beset by roads, telegraph wires, telephone wires, and oil rigs. Mountains were mined. The range was fenced in. The frontier would fall, and the last of the cowboy outlaws would have no place to hide.

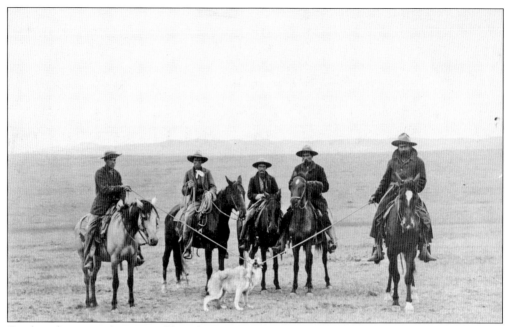

Cowboys have roped a gray wolf on the Wyoming prairie. Predators like the wolf, the mountain lion, and the grizzly—long seen as threats to the livestock industry—were hunted, trapped, and poisoned. On the range, in the deserts, and in the mountains, they were killed off, like the outlaws. (Courtesy of John Grabill, Library of Congress.)

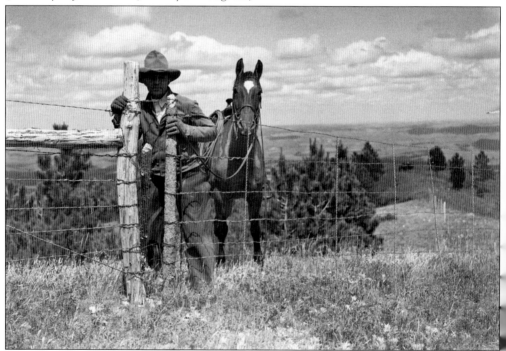

Barbed wire was invented by Joseph F. Glidden and patented on November 24, 1874. It would soon be in use on a commercial scale. The closing in of grazing lands with fences marked the end of the open range and the final victory of the cattle barons over the smaller ranchers.

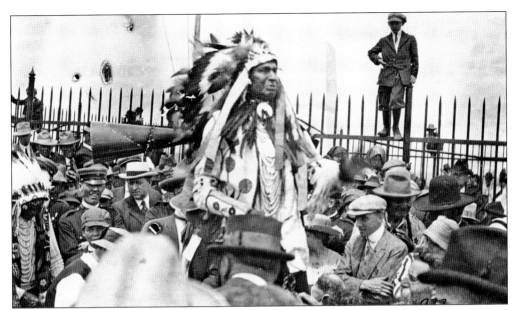

A photograph shows Custer scout and Crow warrior White Man Runs With Him during the 50th anniversary of the Little Bighorn. In a traditional war bonnet, he appears as an anachronism, a man of another time. The West of the Indian braves and the "bad men" had changed. It was no longer theirs.

A telephone line is being erected by workmen in rural Wyoming. Telephone and telegraph wires soon greatly enhanced communications between railroaders, bankers, and lawmen, making well-staged robberies impossible. Along with the roads and railway tracks that crisscrossed the state and the region, they were harbingers of a new era.

A river of felled trees appears on Douglas Creek of the Medicine Bow National Forest in the early 1900s. Although Pres. Teddy Roosevelt increased the Forest Reserve System from 43 million acres to nearly 200 million acres in 1905, timbering at a commercial level still occurred on federal lands under the jurisdiction of the newly created US Forest Service.

This is an image that shows clear-cutting on the Medicine Bow–Routt National Forest of southern Wyoming and northern Colorado in the early 1900s. The undated US Forest Service photograph has writing on the back that states: "Destructive logging followed by fire has completely destroyed the forest and soil erosion has started. . . . When the jacks left it, the naked jagged stumps stood like markers in a graveyard."

This is a gushing oil well near Casper, Wyoming. The Dallas Dome, in Lander, Wyoming, became the state's first oil field in 1885. The industry would quickly change the landscape, bringing roads and rigs to the vast empty spaces where Butch Cassidy, the Wild Bunch, and other outlaws rode with such freedom.

1615-FLOWING OIL WELL CASPER WYO.

Coal mines, copper mines, trona mines and numerous others would be constructed in the deserts, draws, and mountains of Wyoming. The West of the cowboy and the rancher was quickly being supplanted by the West of the miner and oilman. The Susie Coal Mine, near Kemmerer, Wyoming, opened in 1908 and was a prime example of new industrialized mining that became increasingly frequent in the state. It was named after the wife of Kemmerer's founder, P.J. Quealy.

Gen. George Armstrong Custer poses with his brother, an orderly, and a Sioux scout, probably Bloody Knife, over a slain grizzly in the Black Hills in 1874. Bloody Knife's averted gaze may indicate his shame over the killing of the bear, another "two legged," held sacred by many tribes.

The automobile quickly replaced the horse. Starting in 1903, Henry Ford's Model A rolled off the assembly lines. In 1908, the Model T, the car in this image, came into production. The day of the horseback outlaw was over.

Eight

WHEN LEGEND BECOMES FACT

The Old West of the cowboy outlaw never existed. Or at least it never existed as it has been imagined. Through romanticizing the past, it has been made, in the words of Dr. John Logan Allen, "more glorious in the retrospective view than it was in either prospect or actuality." Much of the Old West and the New West have been reinvented—as have the characters who inhabited these landscapes, outlaws like Butch Cassidy and the Sundance Kid.

In the American West, especially the period between the 1860s and early 1900s, Buffalo Bill Cody, Owen Wister, and others modified, invented, and perpetuated the myth of the American West in a variety of ways. One "truth" that became accepted by the public was the near-legendary status accorded the cowboy. The horseback outlaw, the last of the "cowboy outlaws," was also afforded perhaps somewhat more subtly the same status as the cowboy.

The West accepted with gusto the myth that was imposed on it, exalting its golden age of heroes through the use of festivals, films, and art. Most societies invoke a golden age important to the perpetuation of heritage. The outlaw era was Wyoming's golden age. As Dr. J.B. Jackson explains, "First there is the golden age, the time of harmonious beginnings. Then ensues a period when the old days are forgotten. . . . Finally comes a time when we rediscover and seek to restore the world around us to something like its former beauty. . . . The past is brought back in all its richness. There is no lesson to learn, no covenant to honor; we are charmed into a state of innocence. . . . History ceases to exist."

Indeed, we have rewritten our version of Western history and of the outlaw, and in the romantic version of it, realism has largely ceased to exist. As the newspaper reporter famously stated in the film *The Man Who Shot Liberty Valance*, "This is the West, sir. When the legend becomes fact, print the legend." It is likely the legend will continue to be believed.

The horseback outlaw's deeds are still aggrandized by Americans. When it comes to remembering the deeds of the last cowboy outlaws, it is nearly impossible to differentiate between fact and folklore. The citizens of the New West, which started some time in the early 1900s, were nostalgic with this remembrance and others.

The image below portrays Gen. George Armstrong Custer, a Russian duke, and Col. Buffalo Bill Cody. Custer, whether deservedly or not, attained legendary status after the disastrous Battle of the Little Bighorn. As one of the chief inventors of the New West, Cody helped perpetuate Custer's myth, the myth of the cowboy, and others in his famous Wild West Show.

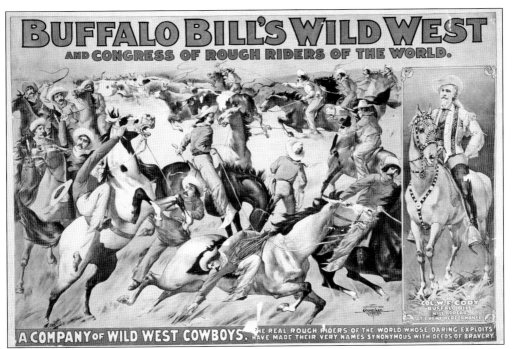

Cody's traveling circus featured cowboys, Indians, and outlaws. The December 26, 1906, *Wyoming Tribune* reported "Col. Cody is planning a movable track and arranging for the construction of a railroad train which is to be run directly through the great arena of his circus, held up by robbers, and these pursued and captured by officers." Cody, always a savvy showman, approached lawman Joe LeFors and former Wilcox robber Robert Lee to participate in the event. (Courtesy of the Library of Congress.)

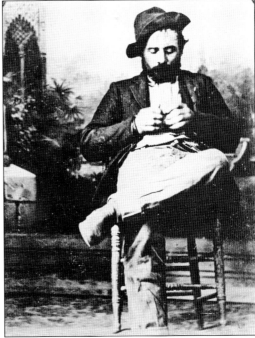

Colonel Cody almost had a confrontation with a real outlaw. A clerk, I.O. Middaugh, was killed in a 1904 bank robbery in Cody. Although it was initially blamed on Cassidy, he was in Argentina at the time, and it had more of the trademarks of Kid Curry. Cody assembled a posse and dashed off in hot pursuit of Curry, "the Tiger of the Wild Bunch." Never finding Curry (shown here), Cody and his friends spent the day hunting and fishing in the Bighorns. Kid Curry's fate is still disputed. He has also become a legend, although remembered less fondly than his more sanguine colleagues.

Circus-goers were amused by the antics of performing animals and actors and dazzled by the marksmanship of Annie Oakley and others. Americans and Europeans were seemingly transported back to a different time, a golden age of the West when history ceased to exist, a time as seen through Colonel Cody's creative lens.

A remarkable performer, Cody lacked business acumen and in later years would suffer financial hardship as well as a strained marriage. He died in 1917 and was buried on Lookout Mountain in Golden, Colorado, overlooking the plains and the mountains of the West that he had loved so much. Thus passed another legend.

Owen Wister, through his works such as *The Virginian*, created a myth of the West that never existed. Wister is seen here (second from right) on a camping trip in Yellowstone. The heroic and individualistic cowboys and characters sensationalized in his literature influenced how Westerners saw themselves and their region.

Artists such as Frederick Remington and Charles Marion Russell perpetuated the same Western myth in their paintings, prints, and sculpture that Wister had in his writings. In this 1910, print titled *Painting the Town* by Russell, a group of buckaroos "hurrahs" a village much in the same manner of the Wild Bunch in the earlier years. (Courtesy Library of Congress.)

In 1903, the *Great Train Robbery*, a groundbreaking silent film and epic Western, was shown in theaters around the world. The movie's makers may have been influenced in part by the Wild Bunch's robberies at Wilcox and Tipton. Importantly, it introduced an image of gun-wielding outlaws reenacting robberies on the big screen. (Courtesy of the Library of Congress.)

Plays and community events celebrating Jesse James, Butch Cassidy, and other social outlaws became increasingly frequent during the Old West's twilight years. To this day, there are reenactments of bad men's escapades from Butch Cassidy Days in Montpelier, Idaho, where the Wild Bunch robs the local bank, to the Telluride Heritage Festival of Telluride, Colorado. (Courtesy of the Library of Congress.)

In honor of Pres. Teddy Roosevelt visiting the "Cowboy State" in 1903, a festival, Roosevelt Days, was thrown in his honor. The small print on the photograph reads, "A bucking bronco showing off for the president." Events such as these continue to perpetuate the mythology of the cowboy, the cowboy outlaw, and the American West. (Courtesy of the Library of Congress.)

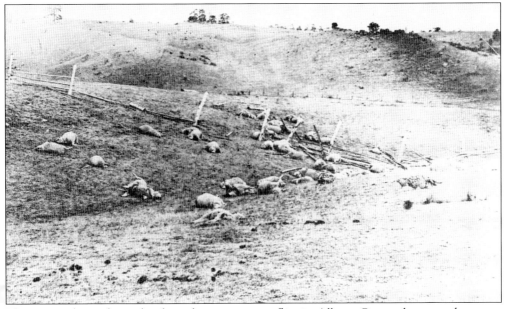

This image shows sheep slaughtered in a range conflict in Albany County between sheepmen and cattlemen. It was taken around the same time as the aforementioned Teddy Roosevelt Days celebration. Although the age of the horseback outlaw was formally ended with the dissolution of the Wild Bunch, the socioeconomic problems that beset Wyoming during the outlaw era continued for decades.

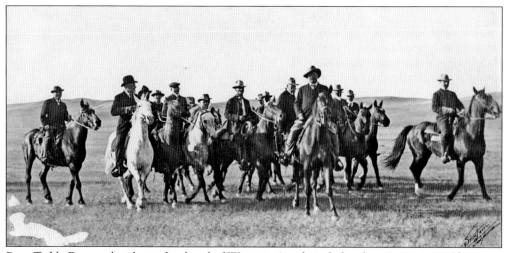

Pres. Teddy Roosevelt rides with a band of Wyoming's political elite from Laramie to Cheyenne in 1903. The original group of politicians, lawmen, and stockmen consisted of more than 1,000 men. Included among these riders are Joe LeFors, Nathaniel Boswell, former governor Amos Barber, and former senator Joseph Carey—all veterans in the outlaw wars.

Tales of buried outlaw loot abound in Wyoming. In the Wind River Mountains near Mary's Lake at the base of a lightning-struck tree; near Cheyenne in a can; and on South Pass in a teakettle, riches reputedly await lucky treasure seekers. These are some of the folkloric tales still told today that enhance the "experience of place" of visitors and citizens alike. (Courtesy Wyoming Territorial Prison State Historic Site.)

The era of the Outlaw Trail and the horseback outlaws will forever be linked to a land of open spaces, freedom, and wildness. The landscape of the American West will probably remain, in the words of Dr. Dydia Delyser, "the most strongly imagined section of the United States . . . the actual West and the imagined [or mythic] West . . . engaged in a constant conversation."

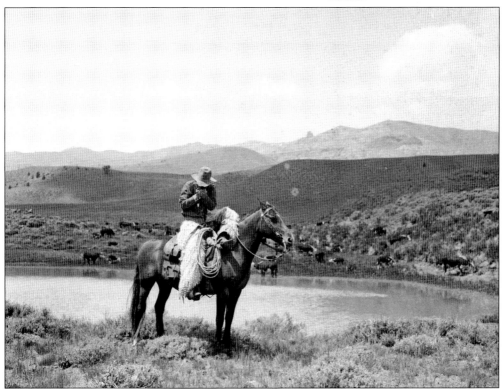

"The great plains are empty; no more do they ring. With the voice of the old cowboy as he yodels and sings. Old Cowboy we miss you. Where have you gone? The old cow range you rode so long and the old mess wagon you made your home, Now stand deserted, forlorn, so alone. . . . From the range forever your voice is still, no more does its echo resound from the hills—Old Cowboy." So wrote Matt Warner on October 31, 1938.

BIBLIOGRAPHY

Delyser, Dydia. "Authenticity on the Ground: Engaging the Past in a California Ghost Town." *Journal of Cultural Geography* 89, 4 (1999), 610.

Frye, Elnora. *Atlas of Wyoming Outlaws at the Territorial Prison.* Cheyenne: Pioneer Printing and Stationery, 2009.

Jackson, J.B. *The Necessity for Ruins and Other Topics.* Amherst: The University of Massachusetts Press, 1980.

Kelly, Charles. *The Outlaw Trail.* Lincoln: University of Nebraska Press, 1938.

Larson, T.A. *History of Wyoming.* Lincoln: University of Nebraska Press, 1965.

Patterson, Richard. *Butch Cassidy, a Biography.* Lincoln: University of Nebraska Press, 1998.

Pointer, Larry. *In Search of Butch Cassidy.* Norman: University of Oklahoma Press, 1977.

Seal, Graham. *The Outlaw Legend.* Cambridge, MA: Cambridge University Press, 1996.

Siringo, Charles. *A Cowboy Detective.* Memphis: General Books, 2009.

Warner, Matt. *Last of the Bandit Riders . . . Revisited.* Salt Lake City: Big Moon Traders, 2000.

INDEX

DISCOVER THOUSANDS OF LOCAL HISTORY BOOKS
FEATURING MILLIONS OF VINTAGE IMAGES

Arcadia Publishing, the leading local history publisher in the United States, is committed to making history accessible and meaningful through publishing books that celebrate and preserve the heritage of America's people and places.

Find more books like this at
www.arcadiapublishing.com

Search for your hometown history, your old stomping grounds, and even your favorite sports team.

Consistent with our mission to preserve history on a local level, this book was printed in South Carolina on American-made paper and manufactured entirely in the United States. Products carrying the accredited Forest Stewardship Council (FSC) label are printed on 100 percent FSC-certified paper.

MADE IN THE USA